THE MINISTRY OF TRUTH

KIM JONG-IL'S NORTH KOREA

EVA MUNZ AND LUKAS NIKOL

INTRODUCTION BY CHRISTIAN KRACHT

FERAL HOUSE

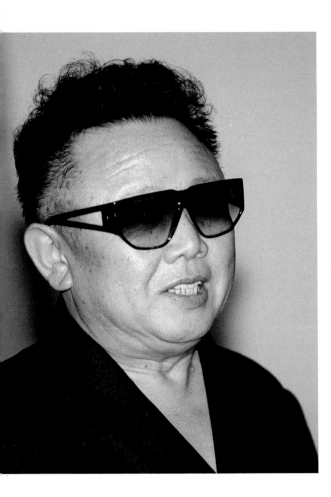

THE MINISTRY OF TRUTH
KIM JONG-IL'S NORTH KOREA

The Ministry of Truth: Kim Jong-Il's North Korea

Introduction by Christian Kracht

»If you want to measure something completely new, use a new measuring stick.«
Kim Jong-Il

When we see images of the Democratic People's Republic of Korea in the Western media, they will more than likely depict a North Korean scientist in front of a clunky instrument panel wearing a white lab coat and mask. Screwdriver in hand, he appears to be at the controls of a nuclear reactor. Vaguely threatening, these images seem to emanate a fear of the bomb, of the horrors of radiation. Such images captured in the nightly news appear to be almost radiated, contaminated themselves: they look like blanched-out, sickly green color photos one finds in a box at the back of the closet. The camera winds its way over desolate hills and valleys until it enters an ominous-looking factory: we seem to have entered an empire of shadows. We see a country on the television screen as if it were something remembered from that fuzzy in-between state of sleeping and waking. We remember, but we don't know exactly what.

Indeed, our imagination of North Korea is created precisely by a lack of images. If we think about it, perhaps what we are seeing are the phantasms of a past we have never experienced. We see a totalitarian dream; we experience a nostalgia that was never really saved on the hard drive. The neurons of memory fire into a void much like the final stage of a rocket ejected in deep space; it is as if our brain has projected onto our retinas the *aphanisis* of Jacques Lacan—the self-annihilation of a subject after coming too close to its imaginary other.

The Democratic People's Republic of Korea could even be a holographic projection, extending backwards into the past and forward into the future, or it might indeed be the setting of an unwritten novel by Phillip K. Dick. It would appear that no place on this planet could be further removed from reality than North Korea. How millions of Koreans live, what they eat, how they get to work, or what they do when they get there—we simply don't know. It is being hidden from us, obscured.

Even those Koreans living in the countryside outside of the capital Pyongyang have no clue as to what happens there, nor do the city dwellers know anything of what happens in the countryside, since special permits, which are never issued, are required to both enter and leave the city. Not only simulated but also projected, mediated reality is the only truth in the Democratic People's Republic. Do the residents of Pyongyang wish to get out? Do the people in the countryside wish to get in? Or is it rather an unfulfilled stream of wishes—an orgone-flow of desire channeled in both directions? Will we ever know? As the economist Paul French writes, »Rarely, if ever, is the life of the ordinary residents shown. Similarly, within the country, Pyongyang is depicted by the state media as the capital of the revolution; hence, many North Koreans have little idea either of the reality of daily existence in the capital. This lack of familiarity with Pyongyang has gone a long way to hiding the nature of daily life in the capital.«[1]

Wait—North Koreans don't know what is going on? But what about outsiders? The few thousand tourists and the handful of foreign journalists and businessmen allowed to travel to Pyongyang in any given year are accompanied by a multitude of minders who guide, protect and, it could be said, distract their guests—the gaze is controlled: they see only what the regime wants them to see. Their vision—and ours—is censored, masked, and projected anew. Kim Jong-Il's People's Republic is a gigantic installation, a maniacal theatrical play that—with all its hermetic meticulousness and its perfect Potemkinization—simulates an entire country. But the question is, for whom? Who should, who may, who must see this dazzling and opulent *mise en scène*?

At the beginning of the 1980s, the frumpy German author Luise Rinser took several extended trips to North Korea before she entered the race against Richard von Weizsäcker for the office of German president in 1984 —and almost won. Together with the founder of the Green Party (and later vehement critic of socialism) Rudolf Bahro, Rinser was allowed to visit »apartments,« »factories,« »hospitals,« and even »prisons« and »work camps« north of the 38th parallel. Mrs. Rinser acknowledged and quickly mastered the requisite mental flipflop necessary to comprehend the staged production—it was only a matter of properly toggling the knob: »I had to smile when I heard that a German television journalist wanted to film a typical village. They told him, ›Come back tomorrow.‹ When he arrived the next day, young girls in festive dress were standing at the entrance to the village holding colorful bouquets. He was supposed to film this, for it was something beautiful. He was outraged. However, it was not an intentional deception but rather a typically Korean moment not only of wishing to show beauty, but also in order to honor one's guest.«[2]

Luise Rinser's analogy is well toggled indeed: »What German *hausfrau* would give her consent if a North Korean television crew suddenly showed up and wanted to film her messy apartment? Would she not say, ›Come back tomorrow!‹ And the television crew would return the next day to find a tidy apartment adorned

with flowers instead of her normally disorganized one...? Would we see this as fraud? North Koreans want to show their country off as much as their pride will allow. Is it not natural that they would put their ›model homes,‹ ›model factories,‹ and ›model kindergardens‹ on display? Would we allow a slum in Berlin-Kreuzberg to be filmed as a model West German neighborhood?«[3]

Take another example: the subway in Pyongyang is one of the most beautiful and architecturally magnificent masterpieces in the world, surpassing even the elegance of the Moscow subway.[4] Its current trains are of the »Gisela« model, which were manufactured by the *Factory of United Railcar Assembly of the GDR—VEB Locomotive Assembly—»Hans Beimler« Electrotechnical Works—Main Plant Hennigsdorf*, which first came into operation in East Berlin in the German Democratic Republic. In 1997, long after German reunification, they were sold to the Democratic People's Republic of Korea.[5] When foreign guests visit a Pyongyang subway station, they will be shown the mock arrival of a train; this choreographed perfection is, however, betrayed by the smallest of details: a soldier reading the newspaper upside down, a passenger who seems unnecessarily obsessed with tying his shoes, or the almost uncanny amount of women decked out in traditional Korean national dress.

Not only Luise Rinser and Rudolf Bahro but many foreign visitors to Pyongyang have reported on this brilliant *mise en scène* of actors miming passersby in order to render a good picture. Supposedly, in Pyongyang there are »showcase« churches in which Christian religious services are held, while in CNN-administered reality North Korean Christians are persecuted, sent to camps, and executed.[6] Fruit and flower stands are erected hastily for foreign visitors in order to suggest their superabundance. While these backdrops serve simultaneously as a means for the foreign visitor and the Korean host to save face, they are also exceedingly elegant tricks to prevent uncomfortable situations from arising in the first place. After all, it is the Americans who are guilty

for the alleged misery of this country—and this appears to be the exceptionally sublime point—then come the Japanese, then everyone else on the planet, and only then the Koreans themselves.

However, North Korea is not just the »other,« the world outside, the projection of the gaze onto the screen. No, these projections do not only serve the other; like the actor who is supposed to portray himself, a kind of turning inside out takes place. These projections serve the »inside,« they are, to an extent, a bluff, a sleight of hand (which Scientologists like to call »leverage«[7]), the Confucian art of saving face, concealment, the entire register of political (hence, social art) which every Korean in the Democratic People's Republic can look to (for reassurance or comfort) at any time. The state doctrine of *Juche*—translated as »independence« (and also as »Korea first«[8])—not only allows for this exceptional thought process but also demands it as the only possible and steadfast communist truth (which, admittedly, is a simulation itself). Various neo-communist groups, socialist parties, Marxist-Leninists, Russian national Bolshevists, German Trotskyites, Nepalese Maoists, Chávez supporters, etc., dispute whether or not the doctrine of *Juche* might be a revisionist aberration within the socialist spectrum. But that is as if the question of the legitimacy of a dynastic line—from Kim Il Sung to Kim Jong-Il and again one day to his favorite son Kim Jong-Chul—must essentially be read as anti-Marxist. No, the son and the grandson of Kim Il-Sung are quite simply the only rightful heirs to the DPRK. Kim Jong-Il is, again in the words of Luise Rinser, »essentially the most capable man in the state.«[9]

This splitting of hairs within the communist camp has been rightly countered by the longtime friend of North Korea, Achim Churs, though also somewhat polemically: »There is certainly a difference when in Germany—with almost ten million unemployed, three million social welfare recipients, and one million homeless—the Potsdamer Platz, the Government District, and the enormous development project in and around the new Central Train Station is built in Berlin with taxpayers' money for that small social stratum

we call the bourgeoisie, as opposed to when a cultural palace in the DPRK is built for which the working masses do not have to pay a cent to enter and use.«[10]

Anti-DPRK propaganda usually consists of widespread horror stories about »cannibalism«[11] (as the sole protein source for a population that has been starving for decades), the »production of drugs and nuclear weapons« as well as »drug trafficking« (as the sole possibility for the chronically cash-strapped government to acquire money). Cannibalism, nuclear weapons, and drug trafficking—is it possible to be more demonized than this? On May 16, 2006, the renowned Japanese daily *Asahi Shimbun*—an affiliate of the *International Herald Tribune*—reported that the Japanese police arrested a ring of gangsters »who wanted to smuggle 200,000 MDMA-tablets out of Korea and into Japan.«[12] Apparently, the cultivation of some seven thousand hectares of opium poppies for the production of heroin as well as the ubiquitous methamphetamine labs are also typically North Korean.[13]

In his recently published pseudo-biography of Kim Jong-Il, the journalist Michael Breen, who lives in Seoul, claims that the Chairman has stashed away some five billion U.S. dollars in Switzerland, money purportedly generated through the production and trafficking of methamphetamines.[14] Anyone who knows anything about the transparency of the Swiss banking system, especially with respect to laundered money, would certainly want to downgrade the propagandistic value of such assertions.

As Larry Wortzel, the former director of the Asia Studies Center in the conservative *Heritage Foundation* has written, however, »If United States space surveillance assets cannot find and confirm the existence of opium poppies, which are brightly colored, seasonal and grow above ground, we will never get adequate intelligence on North Korea's underground missile and nuclear weapons programs.«[15] Perhaps the heresy

must simply be verbalized once and for all. Perhaps there are no underground nuclear weapons factories, no WMDs. Perhaps it is all just a bluff, a projection, a Confucian play. Recent underground testing of a small, less-than-one-kiloton nuclear device, the seismographic effect of which may be replicated by driving and igniting a freight train of TNT into a tunnel, seems to bear this out.

A visit to the film studios half an hour's minded drive outside Pyongyang was an extraordinary experience; on the lot of the state film studios, Lukas Nikol, Eva Munz, and I were allowed to participate in the shooting of a Korean historical film. Men in bright robes and fake beards wielded their swords in front of an old Korean *hanok* house; a Korean film crew filmed them, and the director rehearsed the scene over and over again. He stood up and smoked a cigarette while grips shifted lamps around. It was exactly like a real movie. But when we looked closer, we saw that the camera cable was not plugged in.

Later that evening, back at our hotel, we turned on the television to find none other than ourselves on the screen. There we were on North Korean state television. While attending the shooting of a film especially orchestrated for us—as visitors and honorable foreign guests—we had secretly been filmed. A media Möbius strip revealed itself, from which we have still yet to free ourselves completely. We had become a part of the projection.

The other side, it seems, employs agitprop that is slightly less sophisticated: according to a report on BBC News, a Russian emissary, a certain Mr. Konstantin Pulikowski, traveled in a special train with Kim Jong-Il from Pyongyang for a state visit to Moscow. (Like his father before him, Kim Jong-Il is mortally afraid of flying.) Pulikowski is said to have reported that a helicopter delivered fresh lobster to the Chairman's train daily, which he supposedly dined on with silver chopsticks and a smile.[16] Could this really be true?

Somewhere in the middle of the Russian tundra, a helicopter landed near the train called to a halt, so that the white-hatted gourmet chef could receive a lobster-filled wicker basket? Or did a helicopter with the fresh lobsters land directly on the roof of the speeding train and then pass the writhing crustaceans (their pincers still tied with rubber bands) down a hatch to the train's kitchen so that the train would not have to stop? Could this really be real?

Far more useful than anecdotes about helicopters delivering lobsters, however, are the ruminations of Luise Rinser, who, during a visit to a prison camp in the DPRK, noted: »I still learned something new this time: isolated confinement does not exist. Torture is prohibited, physical torture in any case, but also mental torture. There is no ban on visitors, no censorship of letters, no beatings, no shouting, no humiliation. I think about my own time in prison under Hitler, and also about all the inmates in West German prisons. I think about the RAF in Stammheim. And in the Western press, all one hears about is the dark dictatorship in North Korea.«[17]

What Eva Munz and Lukas Nikol show us in this book is not only the simulation of a simulation or the pictures they photographed and selected of the »first real postmodern country,« but also something entirely new.[18] They give us a panoramic view onto the dear leader's 360-degree, three-dimensional stage set, presenting us with an invitation into his own projection, into his own film. And when we look at Munz and Nikol's pictures, we come to to realize that everything is created for him. North Korea is nothing without Kim Jong-Il and Kim Jong-Il is nothing without North Korea. He is, in his own words, the sun, stars, and the earth all in one. The camera, the screen, and projector, he is the director and the audience. This, of course, is the meaning of *Juche*.

Kim Jong-Il seems to be aware of the fact that images—like all mediation in general—have the tendency to obstruct the very path that they create.[19] In other words, their totalitarian content—their »total meaning«—

always leads to idolatry and religion, and, therefore, must be forbidden. The beloved leader knows, however, about this finely tuned dialectic. So it logically follows that while taking pictures is not forbidden in the Democratic People's Republic of Korea, criticizing them certainly is.

The son of Kim Il-Sung is a great authority on cinema, and, in North Korea, he is without doubt the only authority. Calling this authority into question can have dire consequences: apparently, entire families have »disappeared« forever into the »gulags« of the Korean Northeast because of the utterance of a single critical sentence.[20] Kim Jong-il has written several brilliant didactic books on the art of film, standard works on the relationship of radical Marxist *mise en scène*, and his private collection of films is as extensive as it is legendary. He has arranged—not without a bit of Machiavellian elegance—the kidnapping of several film producers from Japan and South Korea (among these the married couple Shin San Ok and Choe Eun Hui) in order to inject new energy into the rather autochthonic film productions of his homeland. And it should come as no surprise that his favorite music is Pink Floyd.

With this in mind, Munz and Nikol have synchronized their photographs in this book with the only possible way toward understanding the Democratic People's Republic of Korea: Kim Jong-Il's quotations describing how a proper film should be made—a film not only committed to the ideology of *Juche*, but living it, breathing, creating it. Kim Jong-Il's North Korea is the last great maniacal project of humanity, its most monumental work of art. We sincerely hope that our book can contribute in some small way to reunite this brutally divided country.

Berlin, February 2007 (Juche 96)[21]

Translated from German by Richard Langston and April Lamm

1 Paul French, *North Korea: The Paranoid Peninsula* (London: Zed Books, 2005).

2 Luise Rinser, *Nordkoreanisches Reisetagebuch* (Frankfurt am Main: Fischer Taschenbuch Verlag, 1983) 172.

3 Rinser 173.

4 Kim Jong-Il, *Beautiful Pyongyang* (Pyongyang: Foreign Languages Publishing House, 1995).

5 Freundeskreis Erlebnis Bahn, »Nachrichten aus der Welt des Schienenverkehrs«, 2003.

6 Open Doors Deutschland, »Organisation zur weltweiten Unterstützung verfolgter Christen«, 2006.

7 L. Ron Hubbard, *Battlefield Earth* (Los Angeles: Galaxy Press, 2001).

8 Bradley K. Martin, *Under the Loving Care of the Fatherly Leader: North Korea and the Kim Dynasty* (New York: St. Martin's Press, 2002).

9 Rinser 165.

10 Achim Churs, »Wider die Lügen über eine ›Hungerkatastrophe‹ in der KDVR,« Freundeskreis der Juche-Ideologie der KPD.

11 Hyok Kang, *Ihr seid hier im Paradies: Meine Kindheit in Nordkorea* (Munich: Goldmann Verlag, 2005) 137.

12 »4 More Suspects in N. Korea Drug Ring,« *Asahi Shimbun*, English language edition (16 May 2006).

13 U.S. Department of State, »International Narcotics Control Strategy Report,« 2006.

14 Michael Breen, *Kim Jong-Il: North Korea's Dear Leader* (Singapore: John Wiley & Sons, 2004).

15 Larry Wortzel, »North Korea's Connection to International Trade in Drugs, Counterfeiting and Arms,« transcript of a testimony, United States Senate Governmental Affairs Subcommittee on International Security, 20 May 2003.

16 Adam Brookes, »Diplomacy North Korean-Style.« BBC News World Service, 18 Jan. 2003.

17 Rinser 156.

18 Bruce Cumings, *North Korea: Another Country* (New York: The New Press, 2004).

19 Vilém Flusser, *Die Revolution der Bilder* (Munich: Bollmann Verlag, 1995).

20 Kang Chol-Hwang, *Les Aquariums de Pyongyang* (Paris: Editions Robert Laffont, 2001).

21 According to the *Juche* calendar, modern measurement of time begins with the birth of Kim Il-Sung in the year 1912.

»A film must begin on a small scale and end on a large one.
Beginning small and ending large is the general development of life.«
Kim Jong-Il

All quotations throughout the book from Kim Jong-Il's *The Art of Cinema*

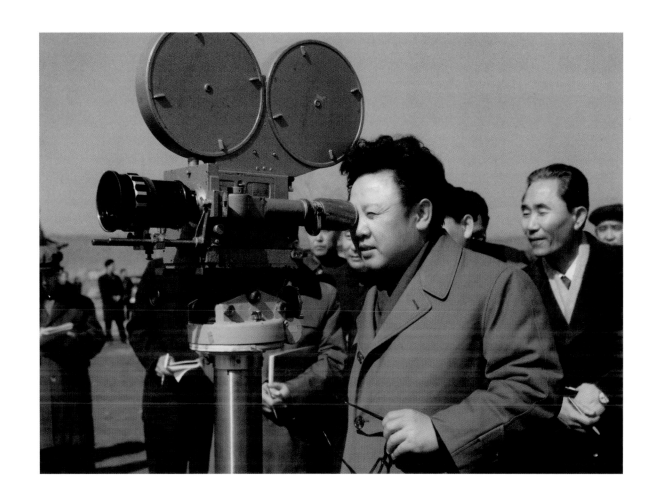

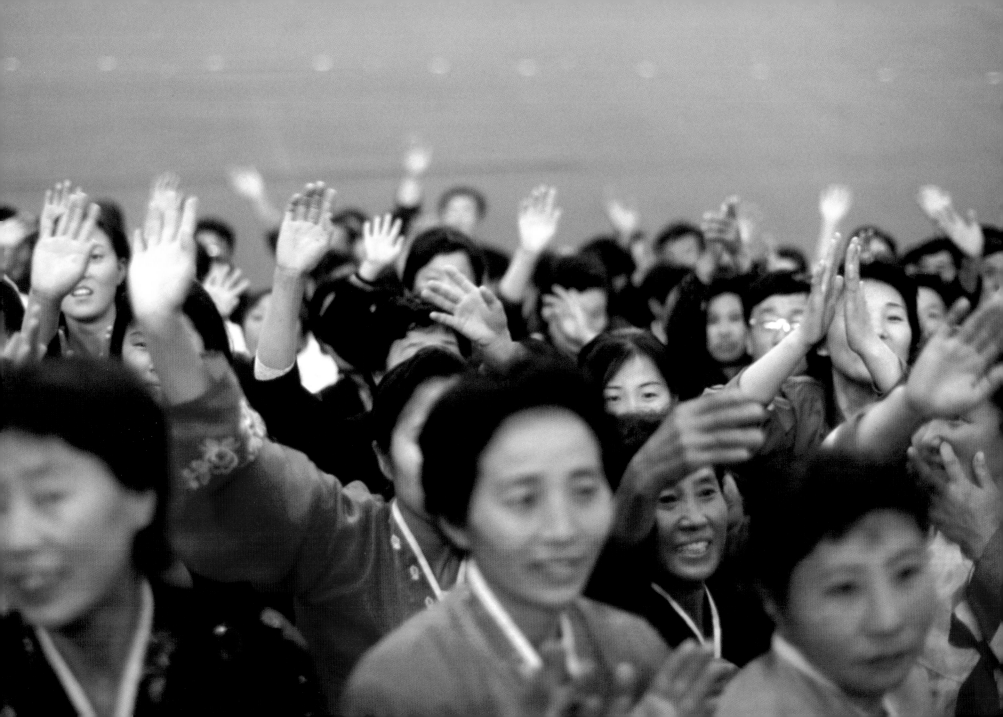

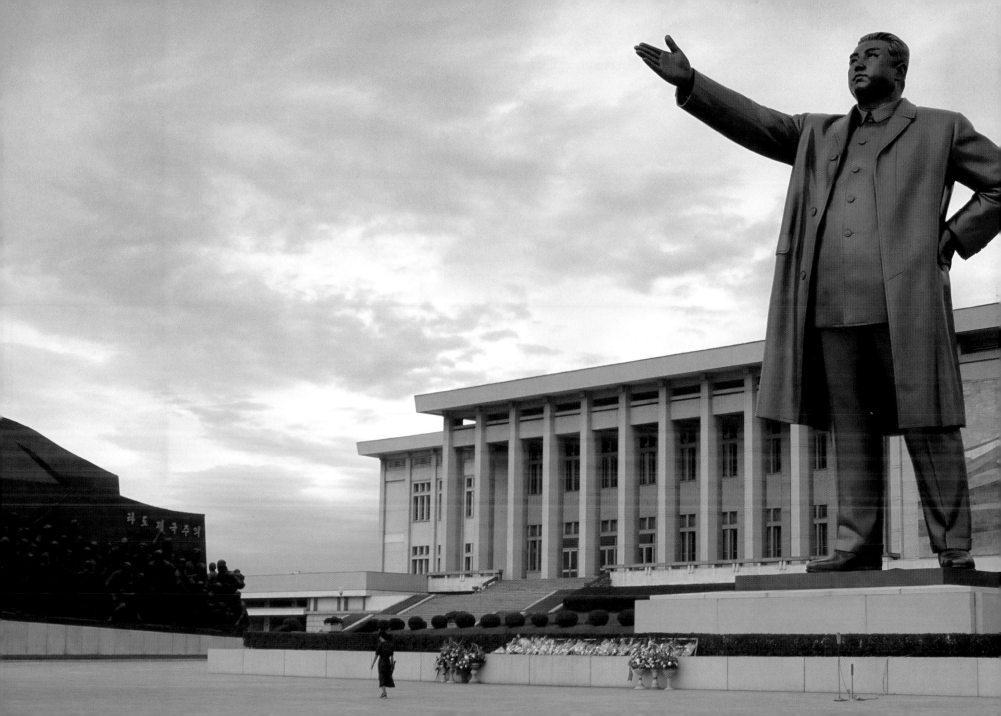

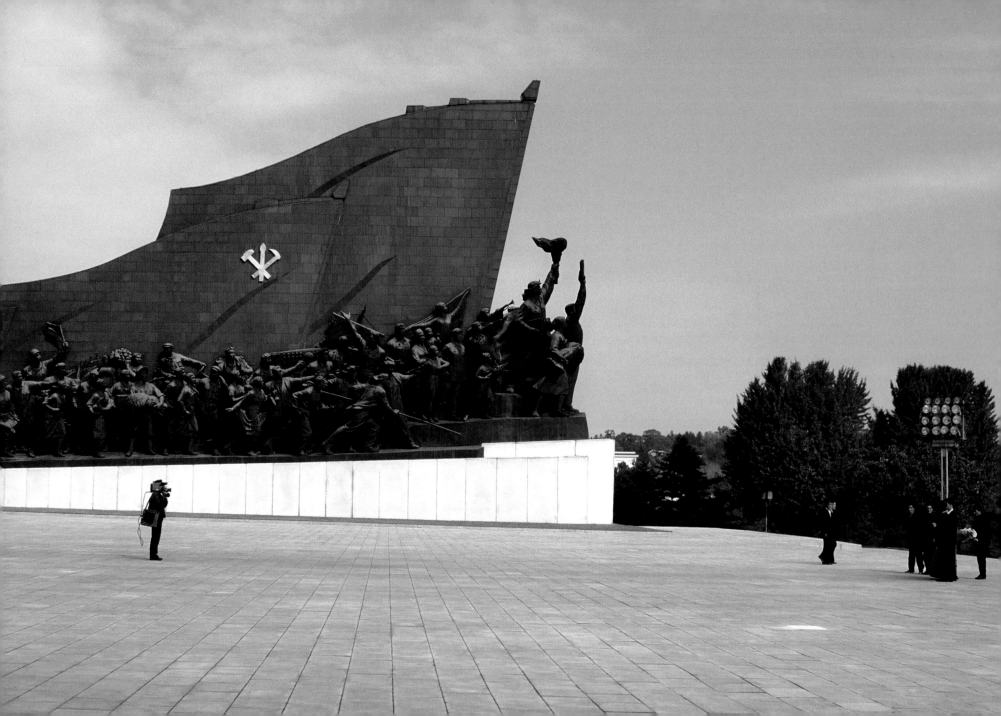

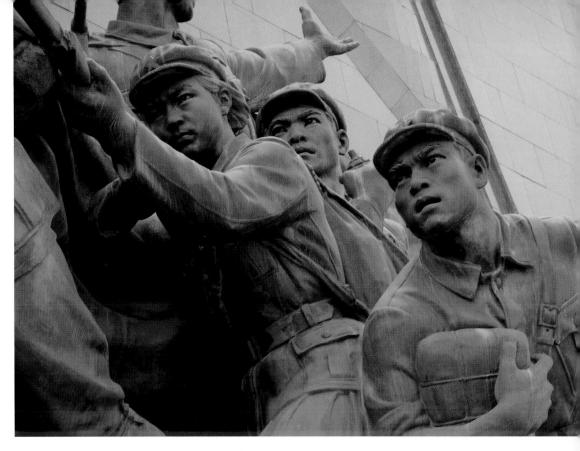

»In socialist society, where the unity and solidarity of the people forms the basis of social relations, and where the positive holds the dominant place, people can be profoundly moved and inspired by the beautiful lives of people who love their comrades and collective and devote their all to the struggle for the country and their fellow countrymen, and by the uncompromising struggle against all the outmoded and reactionary.«

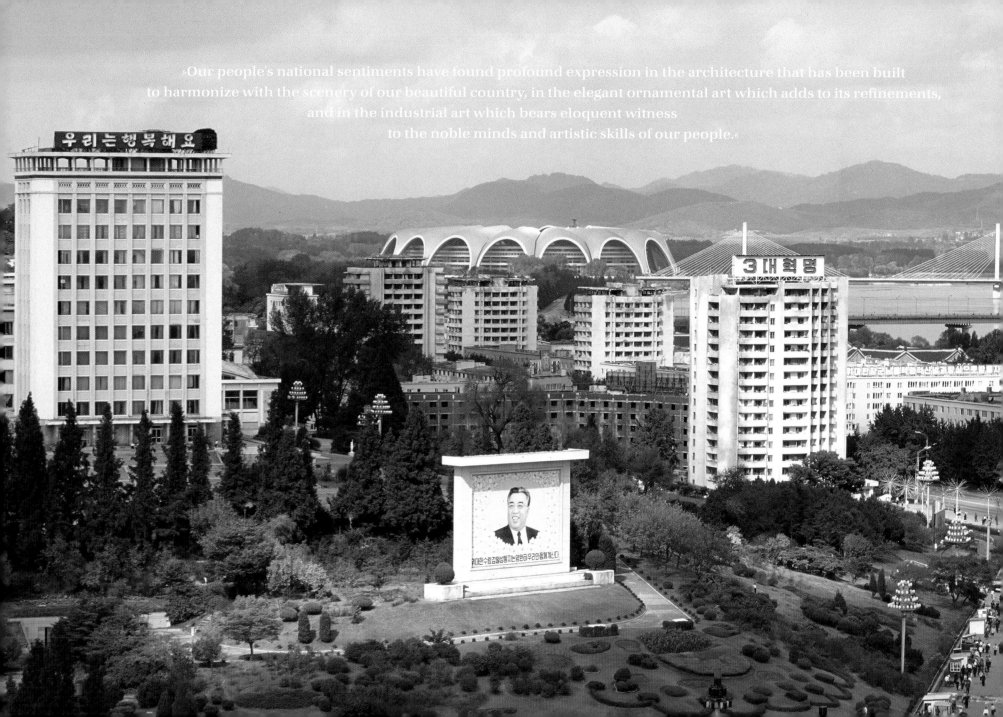

»Our people's national sentiments have found profound expression in the architecture that has been built
to harmonize with the scenery of our beautiful country, in the elegant ornamental art which adds to its refinements,
and in the industrial art which bears eloquent witness
to the noble minds and artistic skills of our people.«

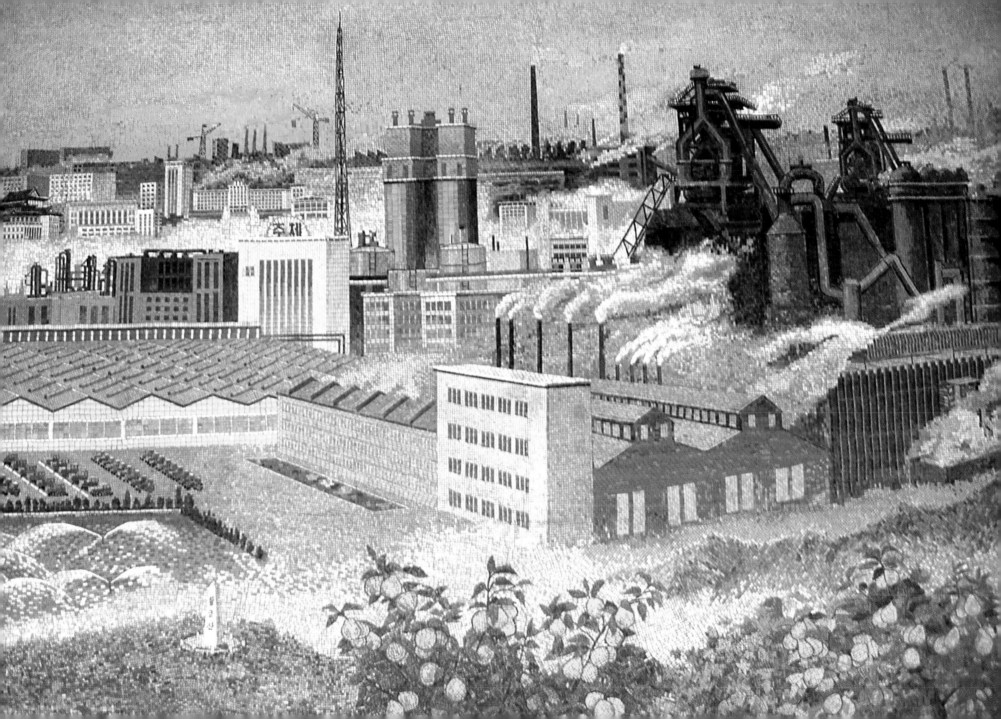

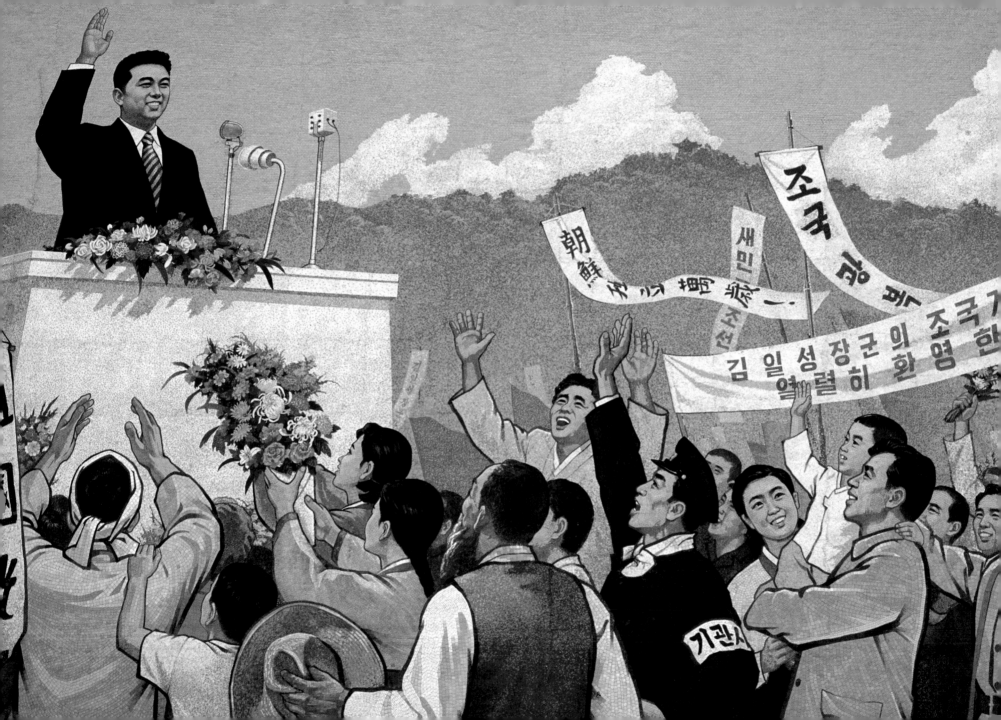

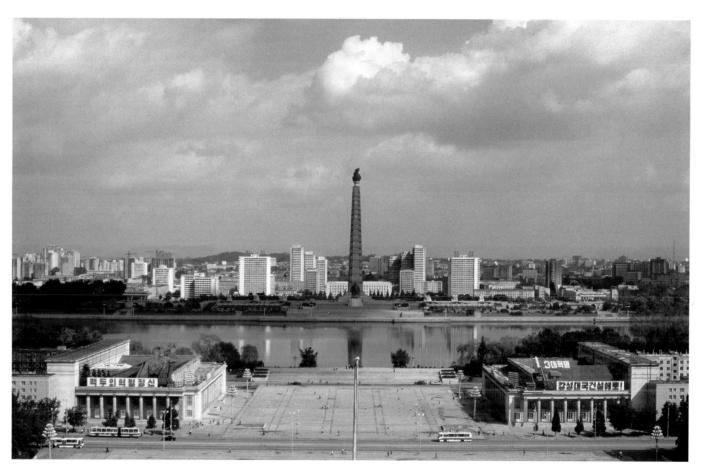

»One can command a general view of a large, imposing building such as the Grand Theatre from a certain distance. A mural can be clearly viewed from a point at which the image of the people in it are distinct. If one stands too close to the mural or too far from it one cannot fully appreciate it. In similar fashion, objects and phenomena can only be clearly understood at suitable distances.«

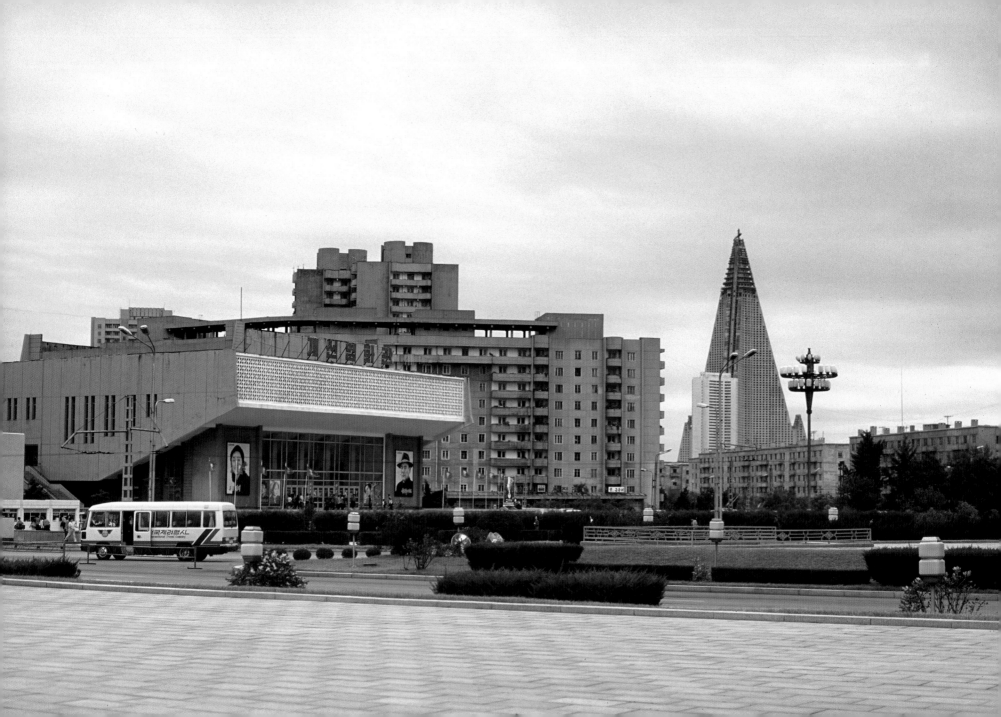

»From olden times, our people have lived in a beautiful land of golden tapestry, have demonstrated resourcefulness and wisdom and an unusually highly developed aesthetic sense. Throughout their long history of five thousand years, our people have developed a brilliant national culture and created a variety of beautiful national forms of art.«

»The psychology of the people should also be taken into consideration in stimulating the feeling of tension.
It is not possible, nor is it necessary to maintain a high level of tension from start to finish.«

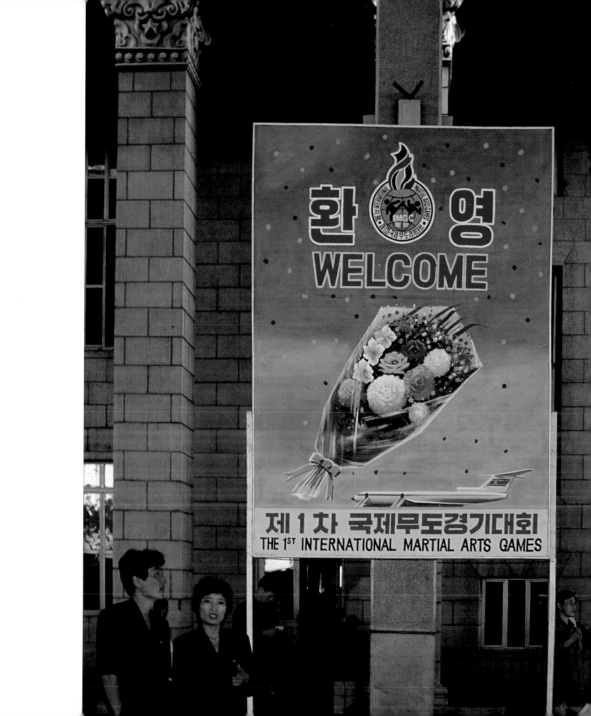

»If a character is to be captured faithfully in the process of filming, his personality must be revealed trough his actions. In whatever form the character may be portrayed, he is influenced by his environment and he reveals his thoughts and emotions in his reaction to it. The cameraman can therefore only cast accurate light on a character's inner world by faithfully reflecting the relationship between the character and his environment.«

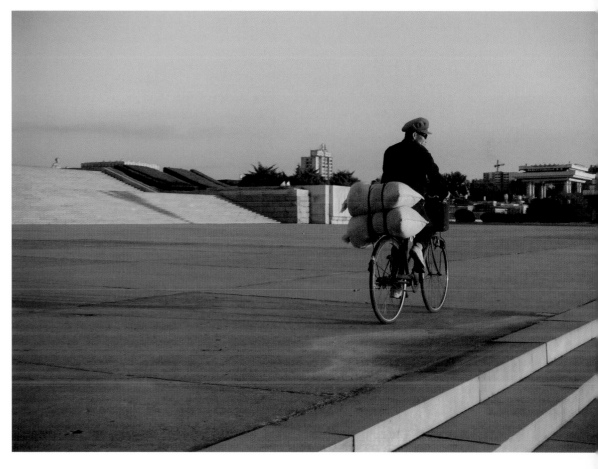

»Nothing is more monotonous than a book which lacks lifelike images of individual characters.
A work of this kind is inferior to articles on political subjects or news items,
because it does not show the reader actual people and their lives in a convincing manner.«

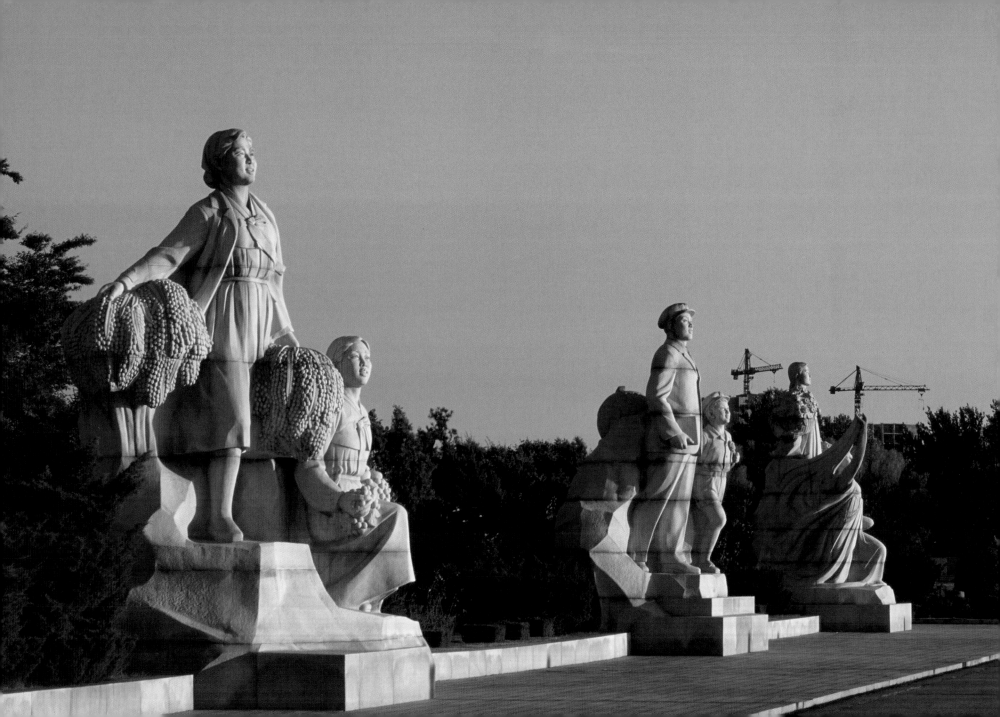

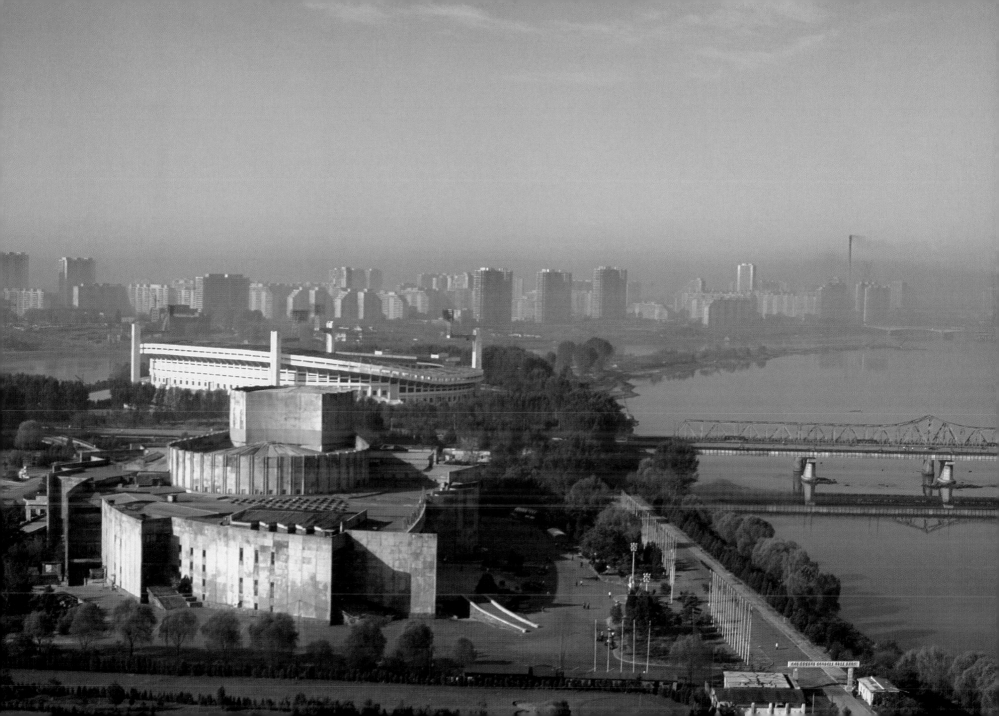

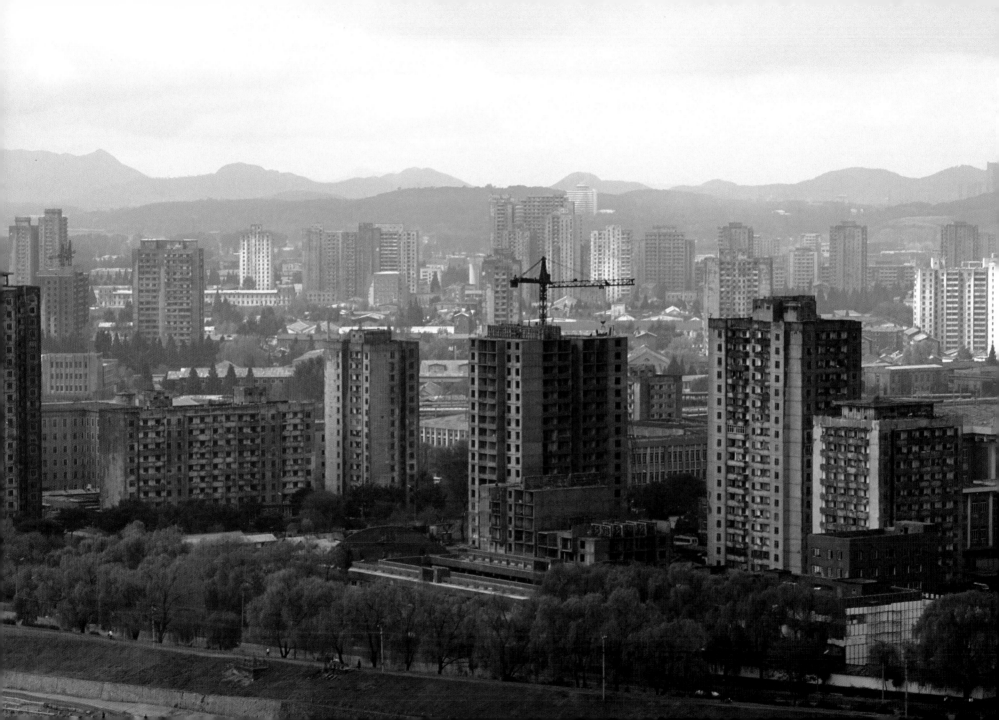

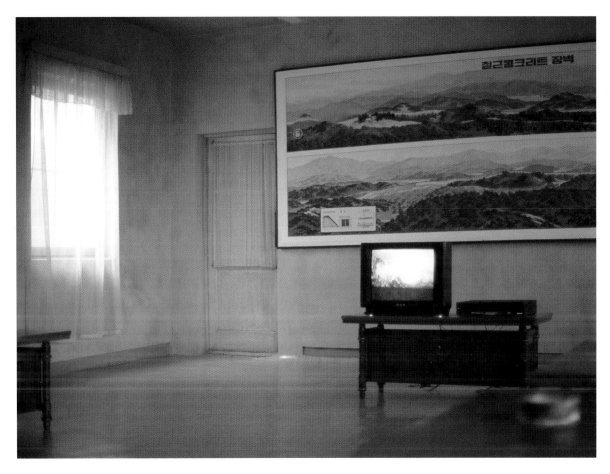

»Emphasis on and praise of the positive imply of themselves an attack on and criticism of the negative, and the affirmation and defense of socialism signify of themselves the denial and criticism of capitalism.«

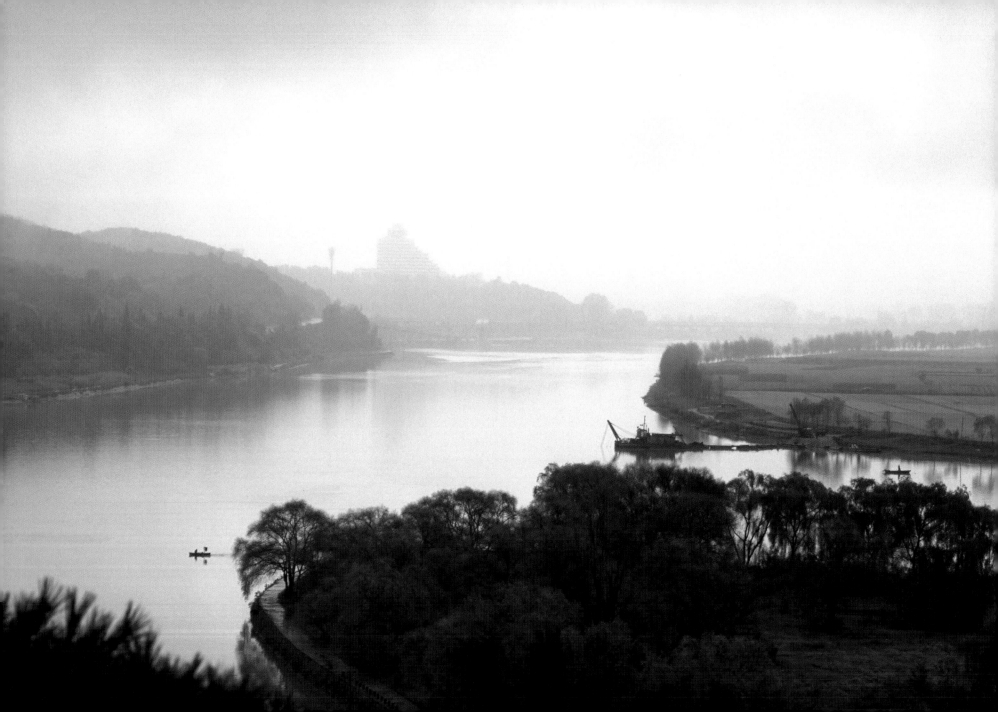

»A character and his life have to be brought into focus in the camerawork if a faithful screen portrayal is to be created.
Cinematic images are a reflection of human life.
A faithful and adequate screen portrayal cannot be divorced from human life, and the cameraman can only create it
when his interest is focused on the life of man, while still encompassing natural and other phenomena.«

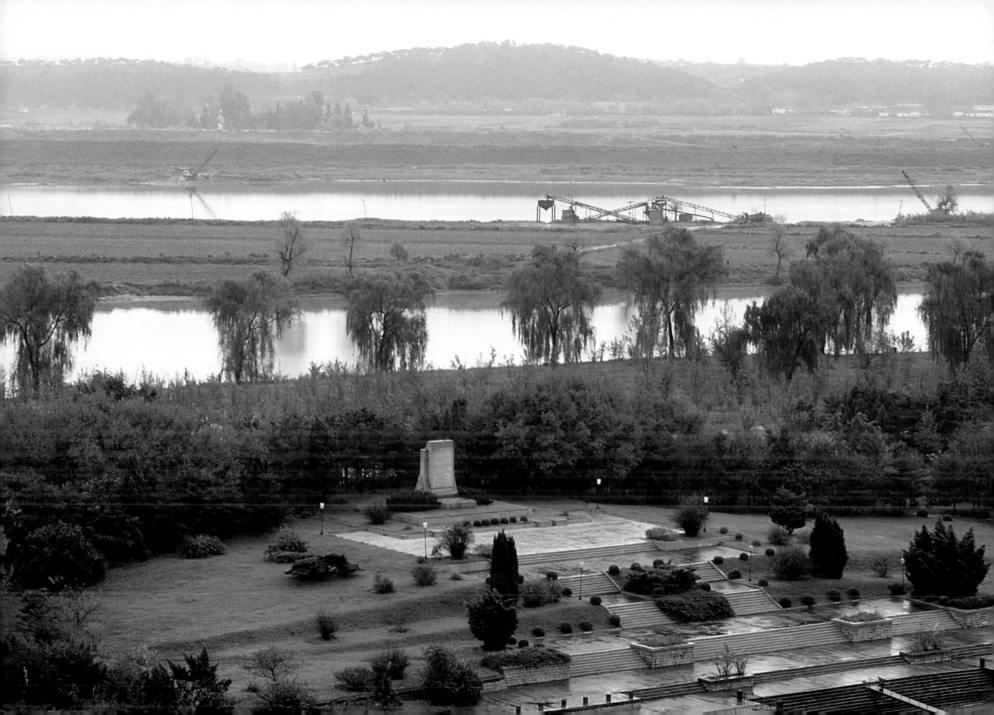

»Artistic generalization is effective because it does not show a hundred facts with a hundred strokes,
but because it creates a hundred facts with one stroke.«

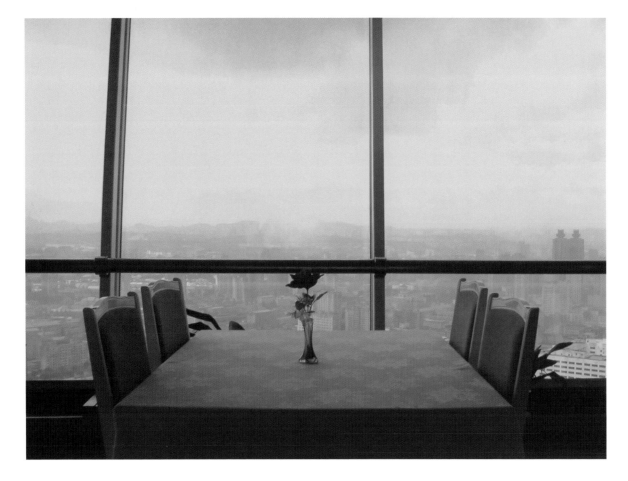

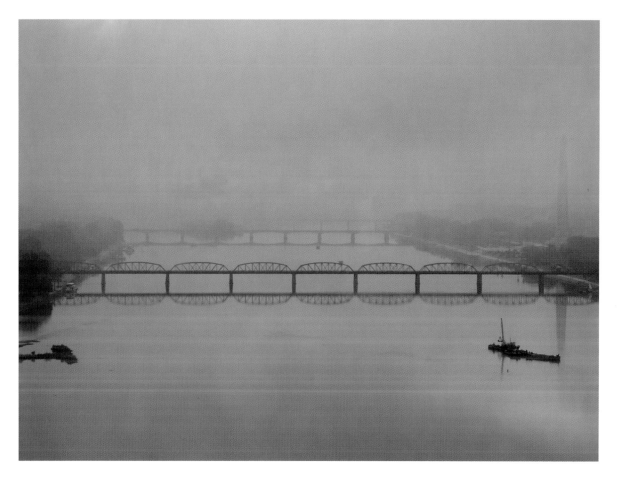

»Putting a hundred things on the screen in order to show a hundred things cannot be called cinematic portrayal.
An able cameraman uses a single minute detail to depict a man and his life in their entirety,
and at the same time he provides a clear characterization of an entire age.«

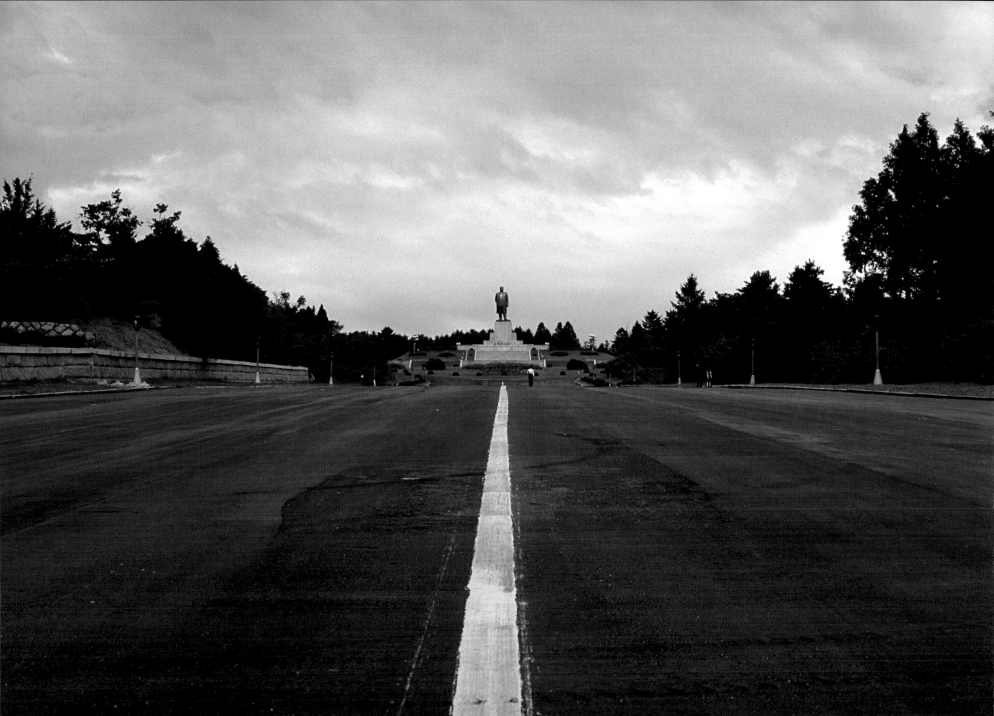

»The scale of life should not be mechanically enlarged
just because a wide-screen film has the potential ability to depict life with more realistic scope and depth.«

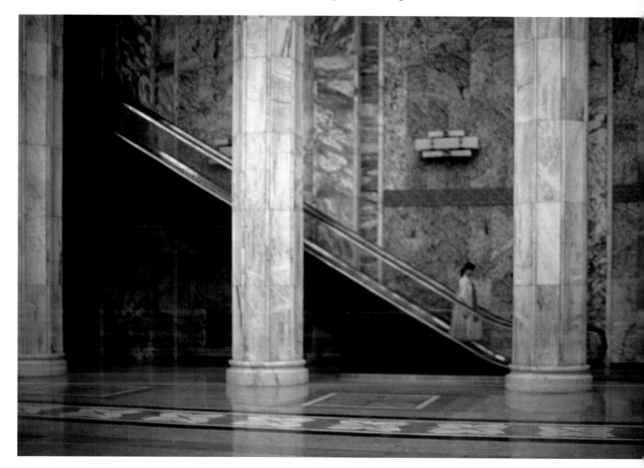

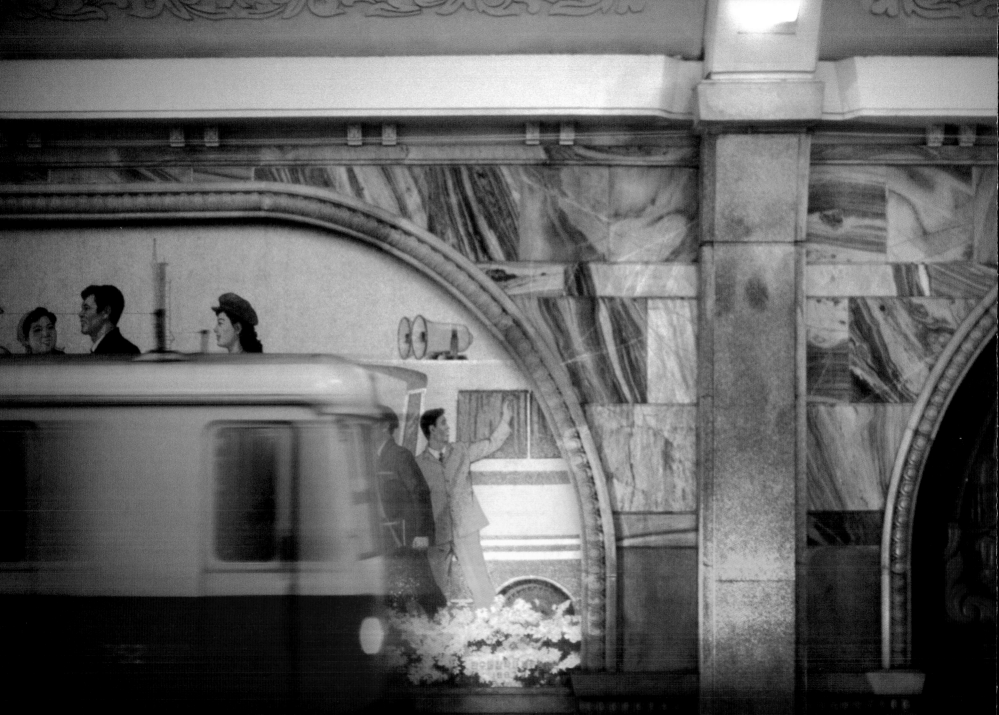

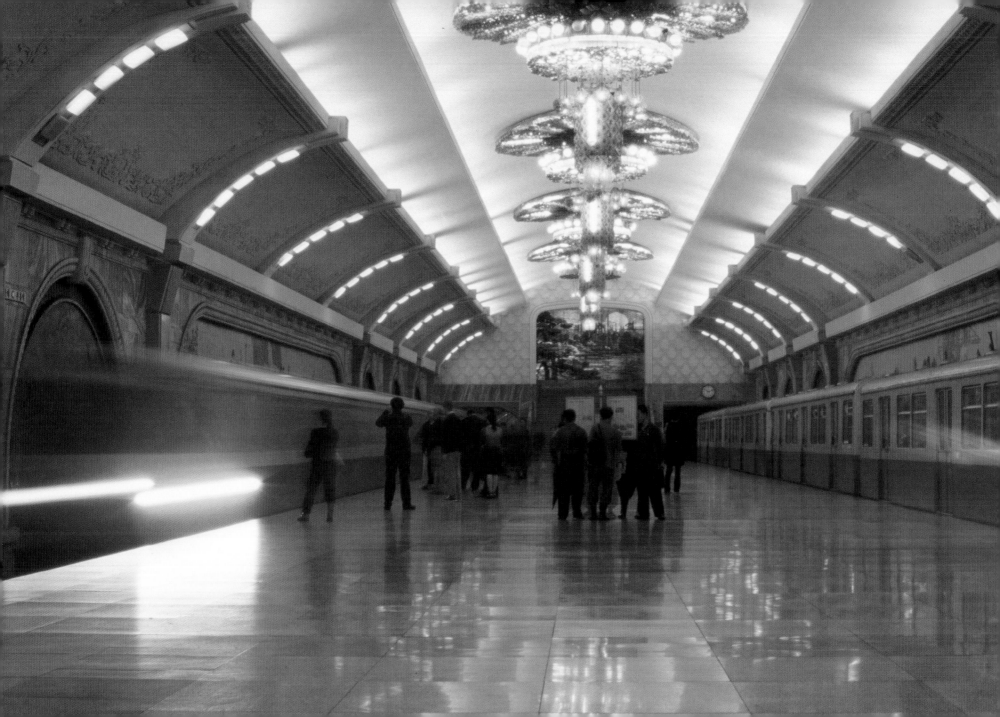

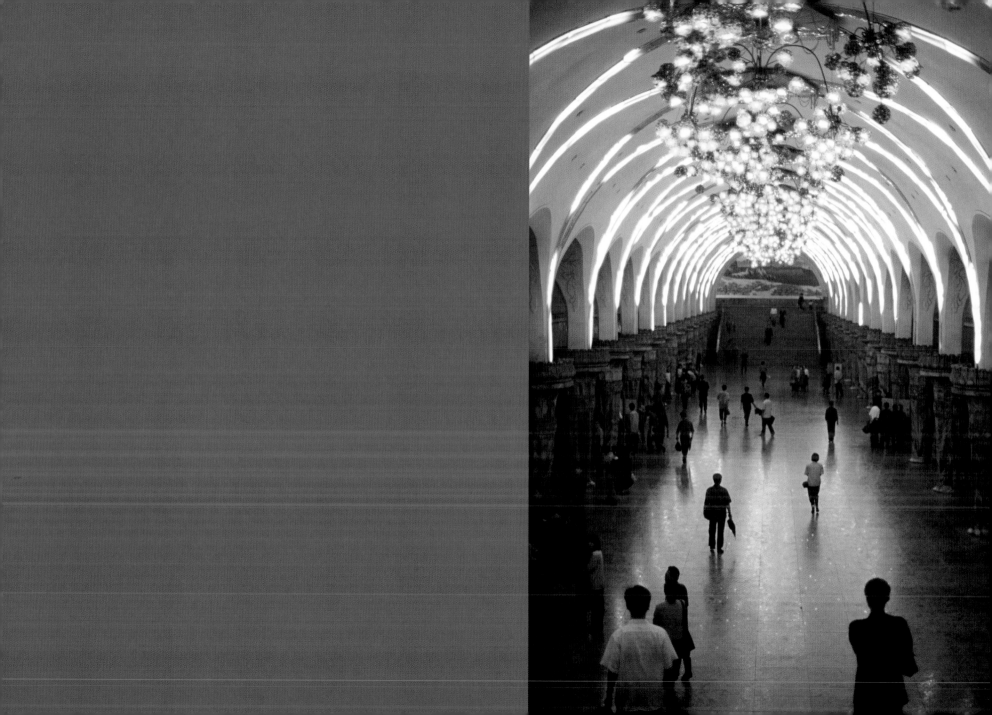

»A man's ideological consciousness cannot be seen or measured.
His actions provide the only yardstick
by which to judge his ideological standpoint,
or his attitude and views in general.«

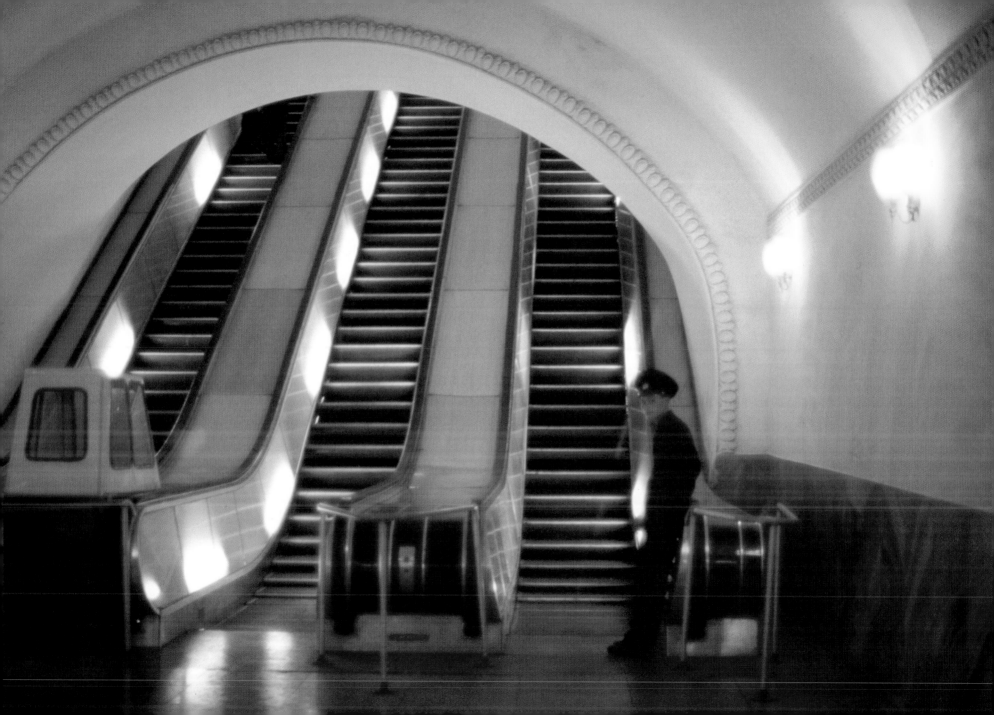

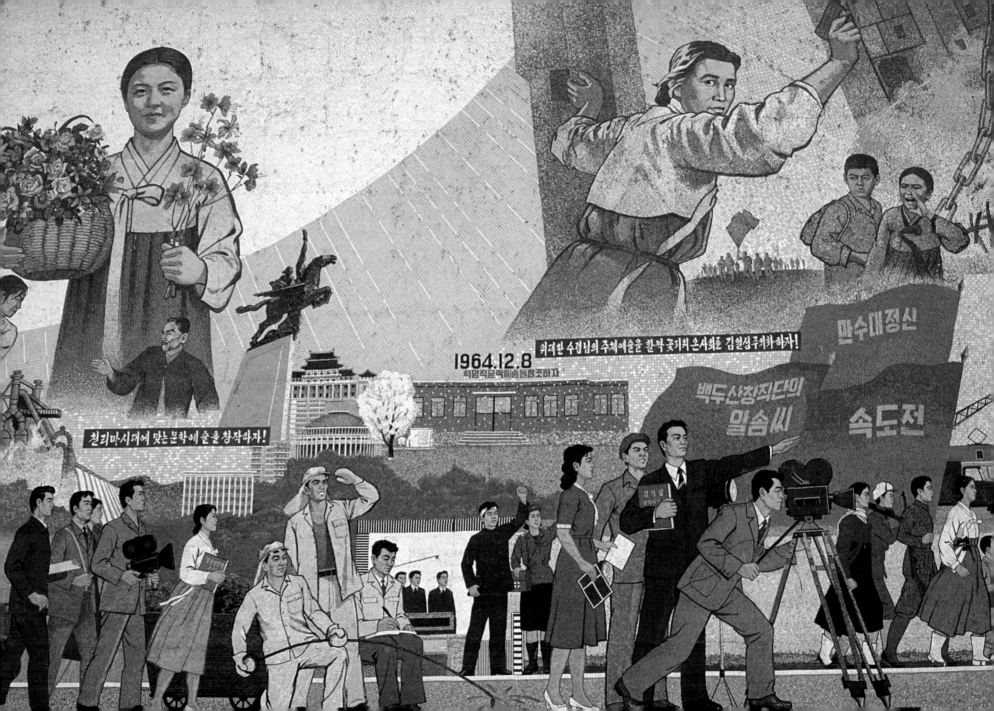

»A great idea can be depicted by something which expresses
the essential nature of life, however tiny and commonplace it may be.
There are ›artists‹ who are incapable of even telling the story
of a family or a single person, yet they brag that they are raising problems
that are vital to the whole of humanity.«

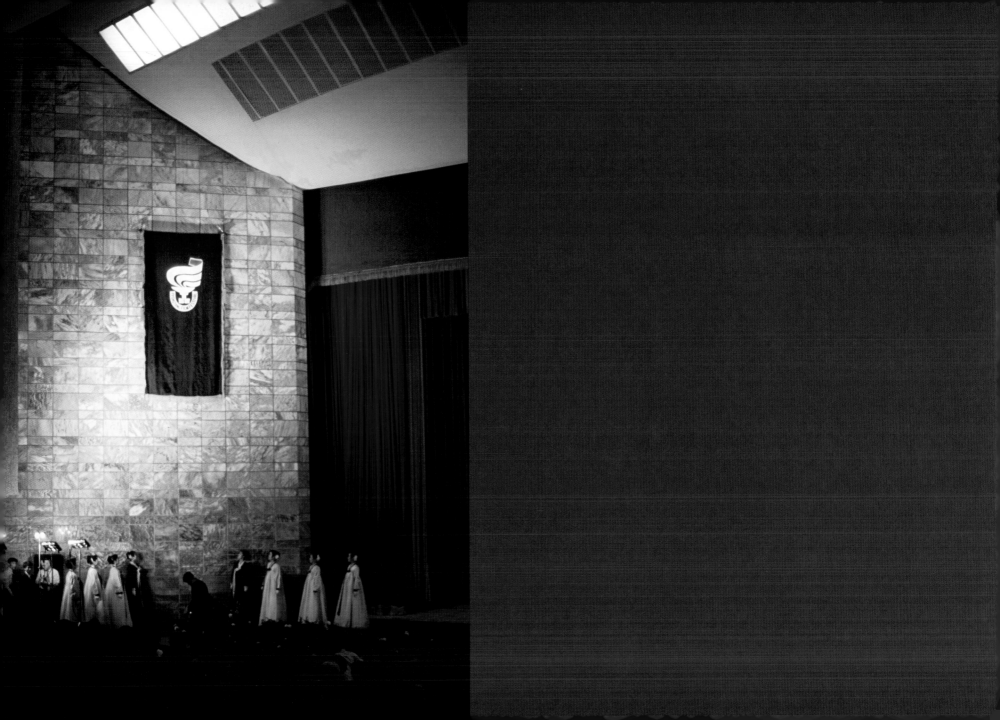

제9차 평양영화축전 · THE 9th PYONGYANG FILM FESTIVAL

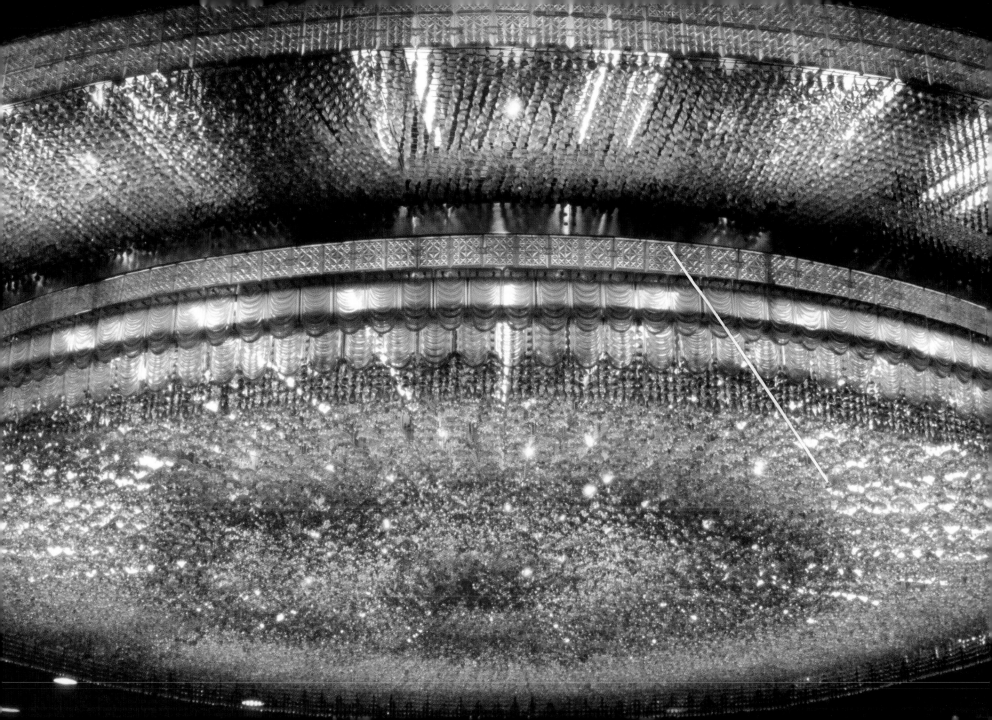

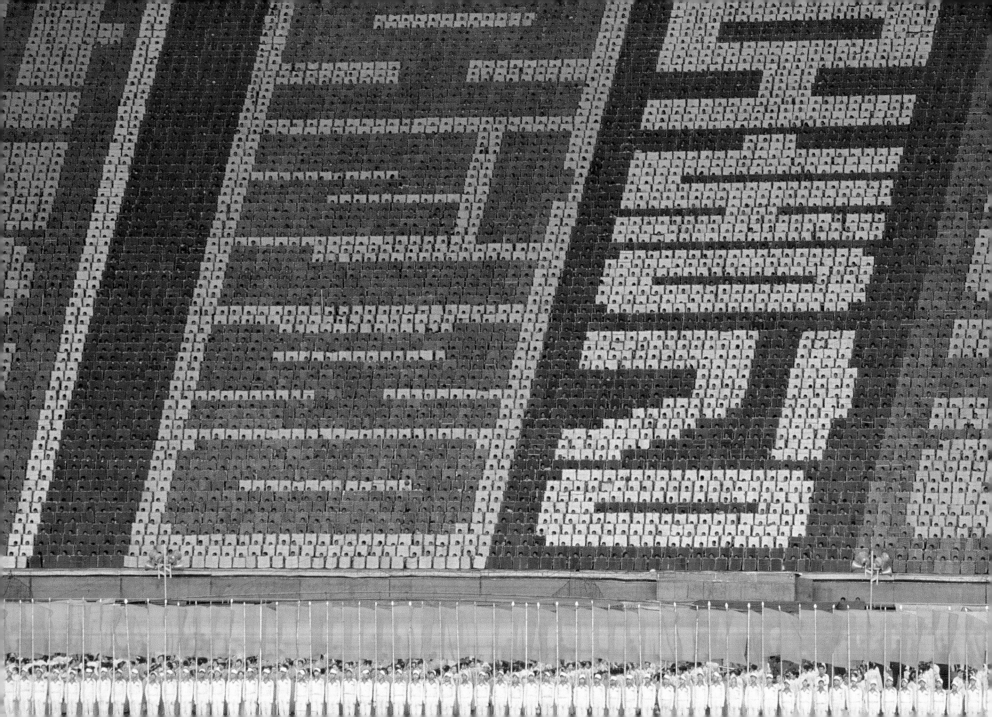

»A person's actions are always typical of his character. Even when people have common ideas and objectives, their specific actions differ according to their level of ideological consciousness and general culture. People act different even in the same situation, and even when they do act in a similar fashion no person ever repeats an action in exactly the same way.«

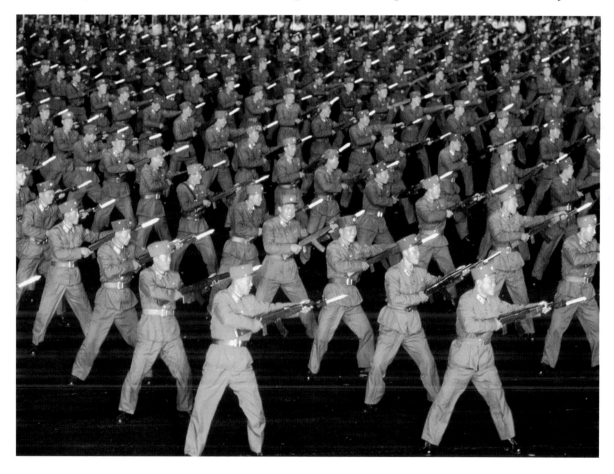

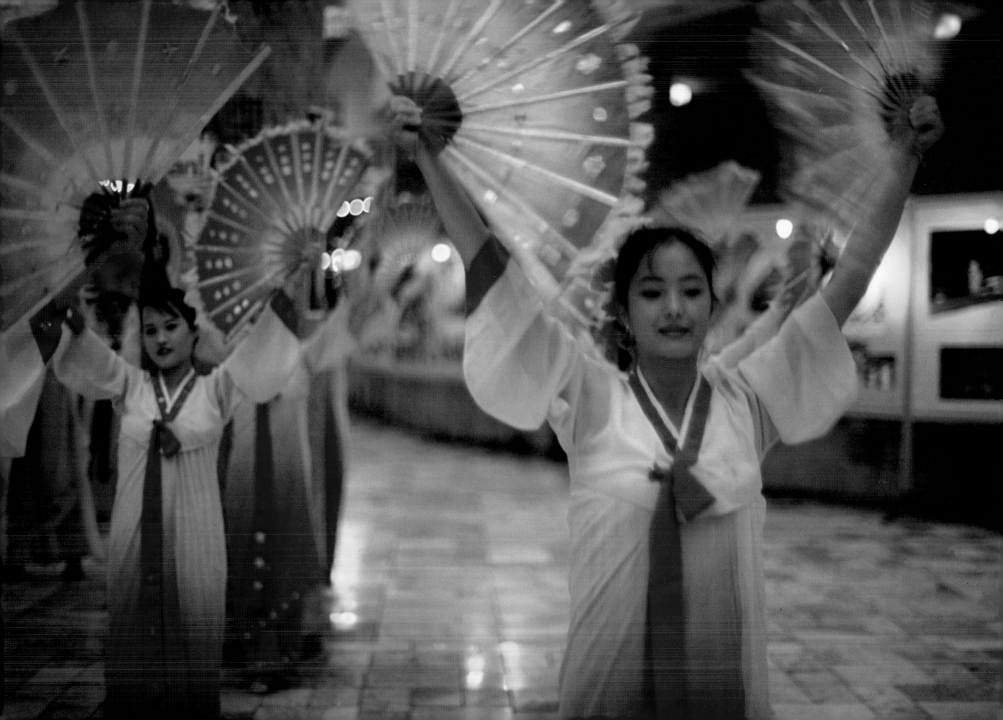

»Our national costume is widely known throughout the world for its beauty and elegance.
Korean clothes are unique in form, pattern and color, and possess great grace and simplicity.«

»We can, of course, obtain clear,
 soft and light colors that are congenial
to our people's tastes and sentiments
 even by using foreign paints.
 Needless to say, however,
 their quality cannot match that
of our own paints which reflect our people's
 unique sense of color.
Only paintings which use our own colors
 is true Korean painting.«

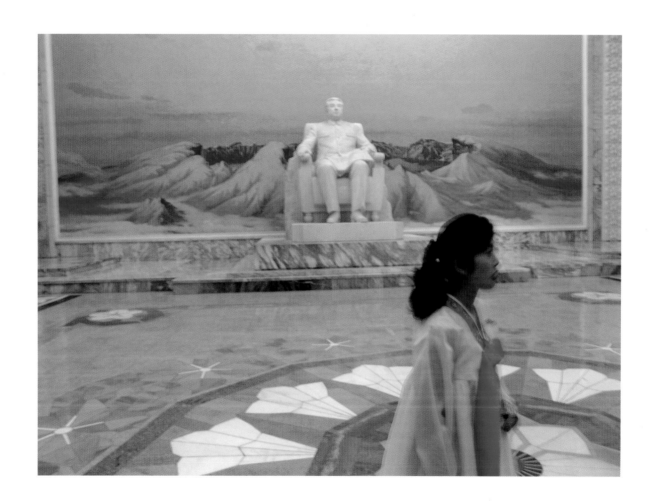

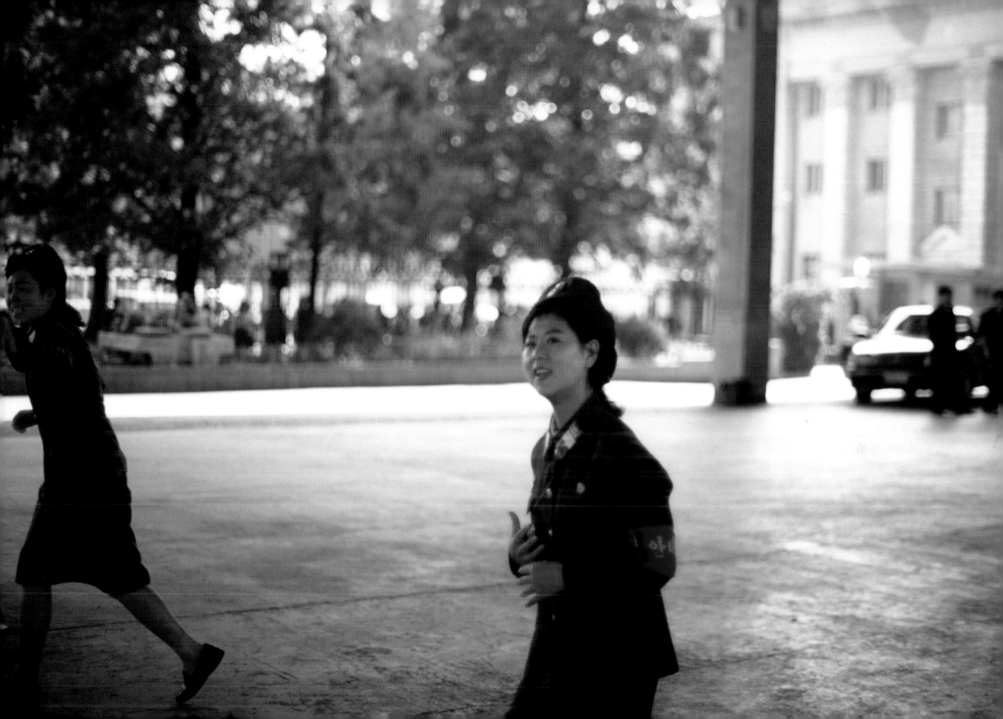

»Where there are people, there is life. People cannot exist outside real life. Human problems, too, do not exist in a vacuum; they only arise within life.«

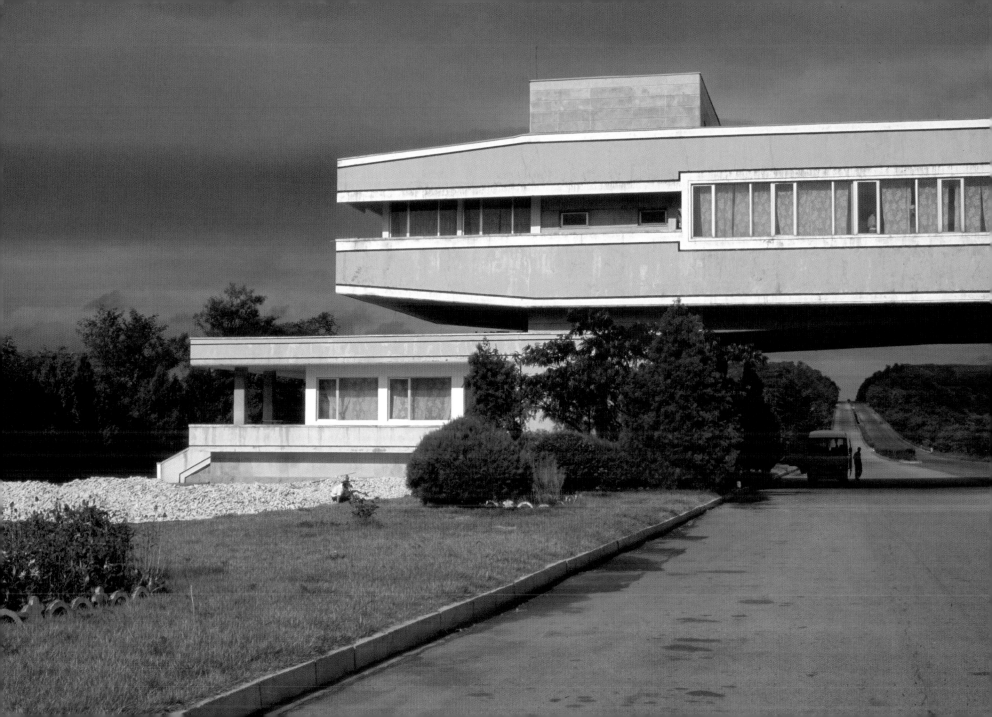

»An appropriate precondition drawn from real life is essential in preparing the escalation of emotions.
In the presence of such a precondition, an emotion emerges naturally.
A merely logical connection of incidents does not bring about the buildup of emotions.«

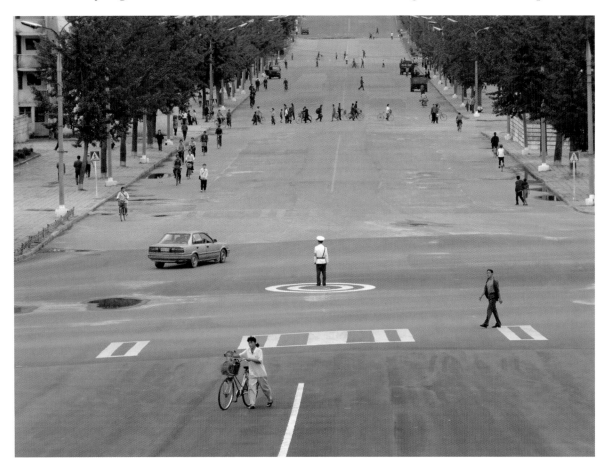

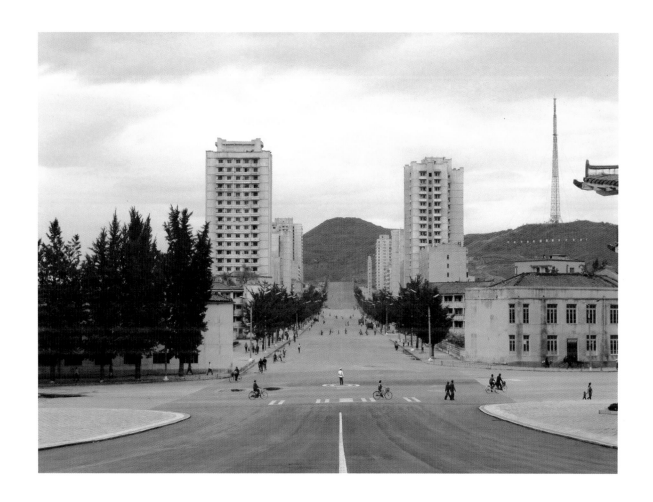

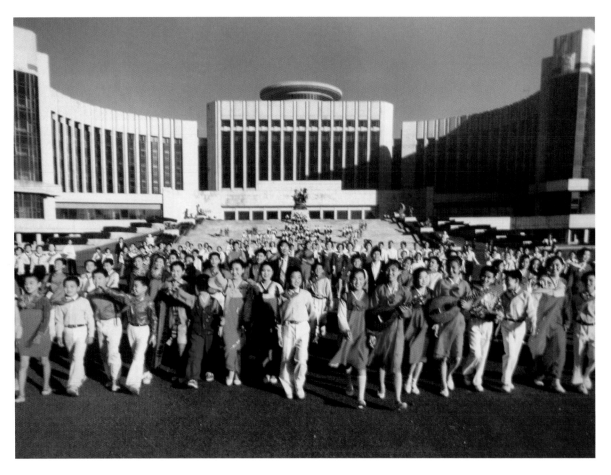

»The freer man is from the fetters of nature and society and from worries over food, clothing and housing,
the greater his need for art and literature.
Life without art and literature is unimaginable.«

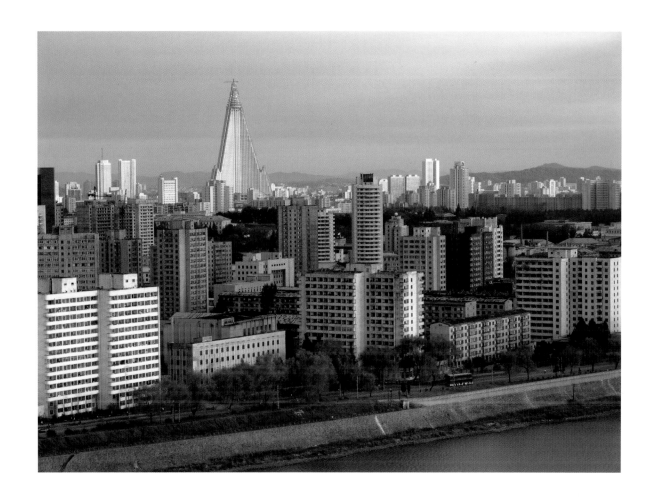

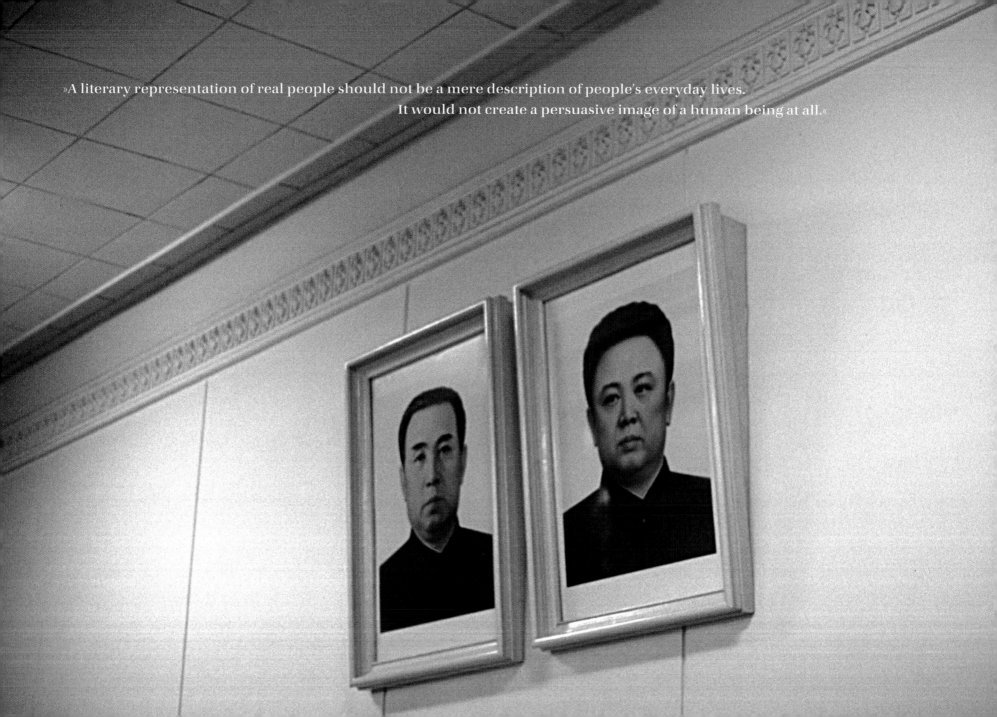

»A literary representation of real people should not be a mere description of people's everyday lives.
It would not create a persuasive image of a human being at all.«

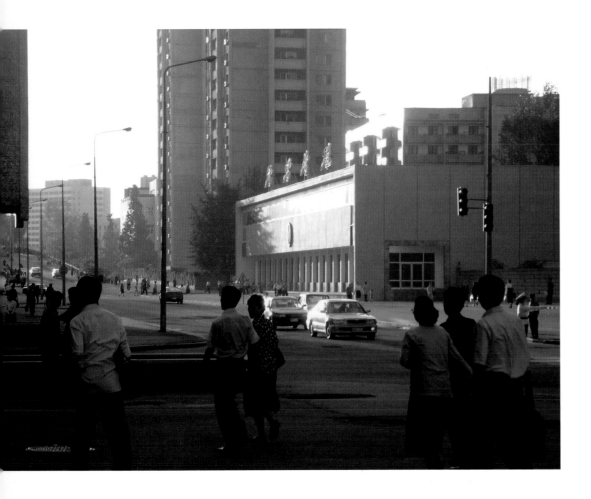

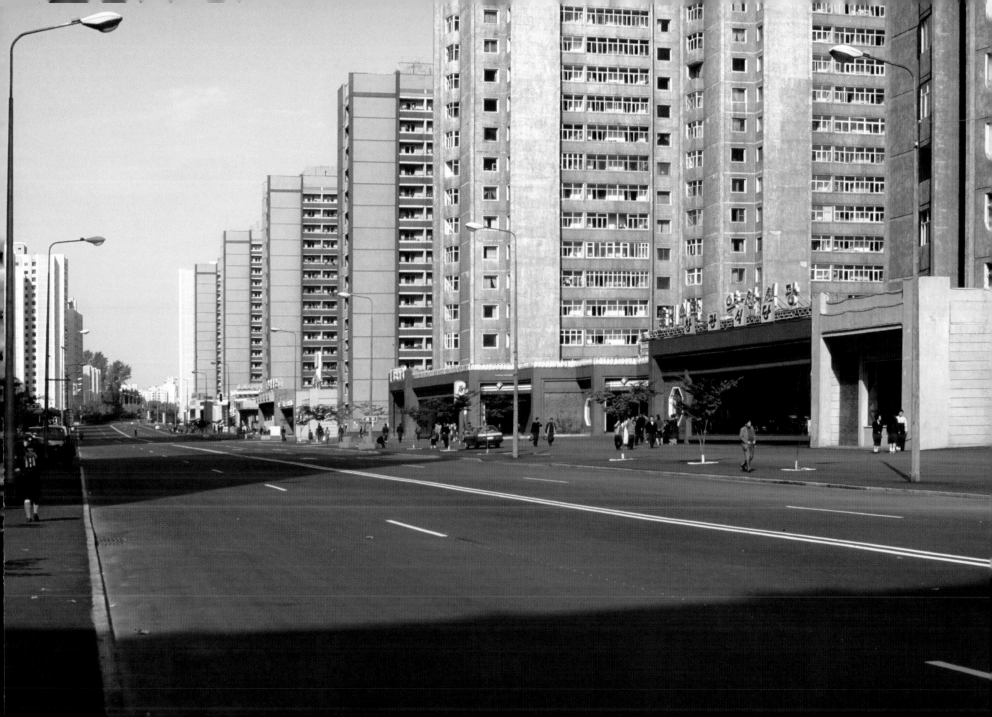

»The beginning must be quiet, and yet interesting.
Artistic interest must always be provided
by fresh insight into the profound meaning
of everyday life and one's own involvement
in the uplifting endeavors of the real world.«

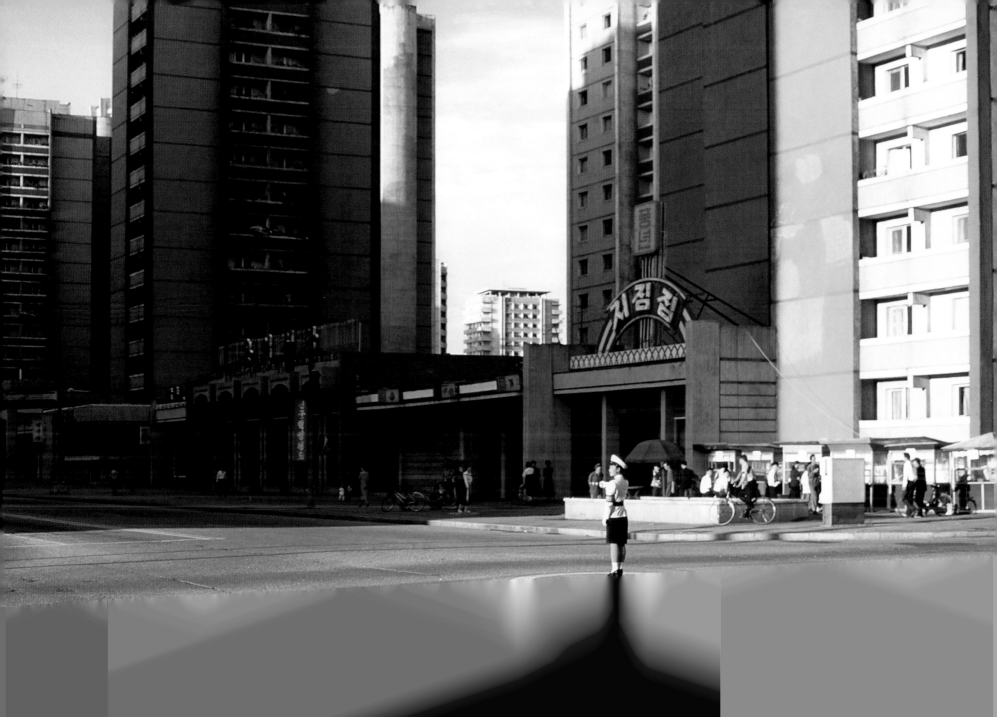

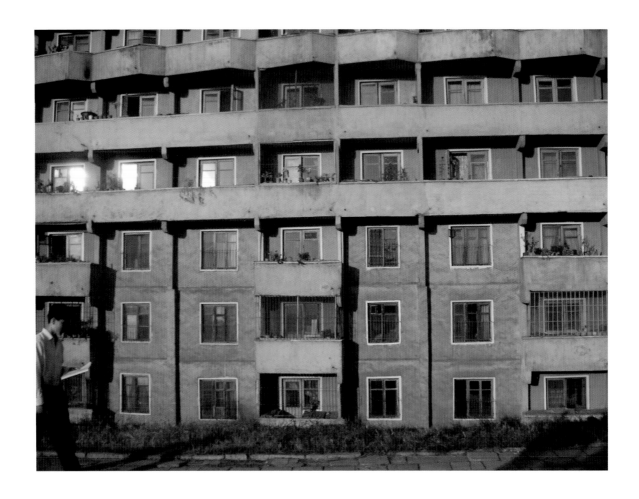

»The houses of today are different from those of the past and the furniture and ornaments of today are not the same as those of the olden days.

The architecture of our times is developing along the line of an appropriate combination of socialist content with national form, and furniture and ornaments are being made which conform with the socialist pattern of life.«

»The major stimulus to people's emotional response is life itself. Various feelings like joy and sorrow,
which are experienced by every person, result from the relationship between the person and his situation.
Human emotions cannot exist outside of real life. Accordingly, the delineation of the emotions in drama
is only clear and accurate
when it accords with the logic of life.«

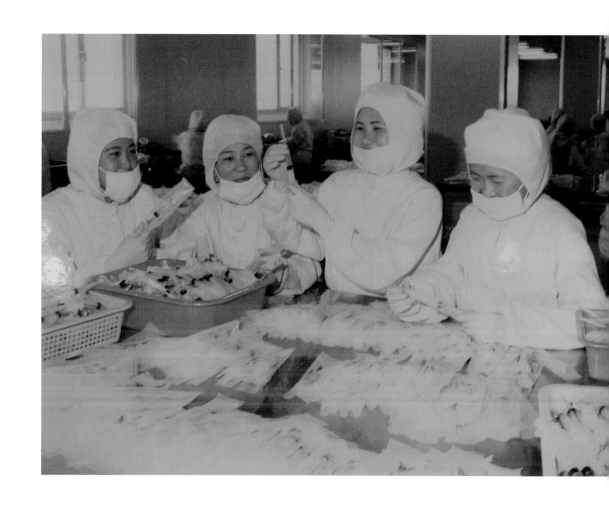

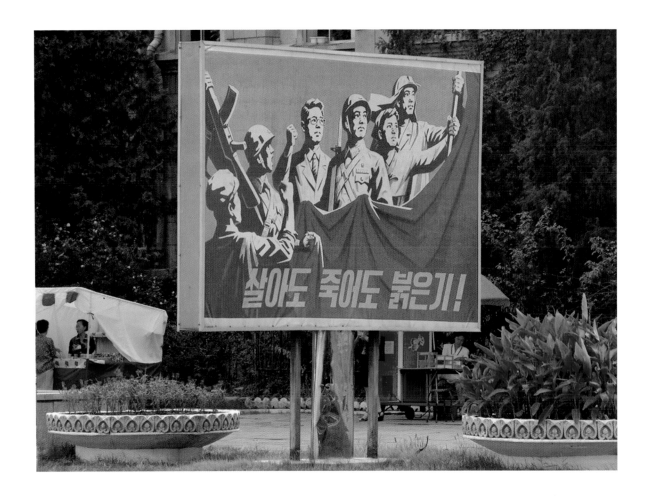

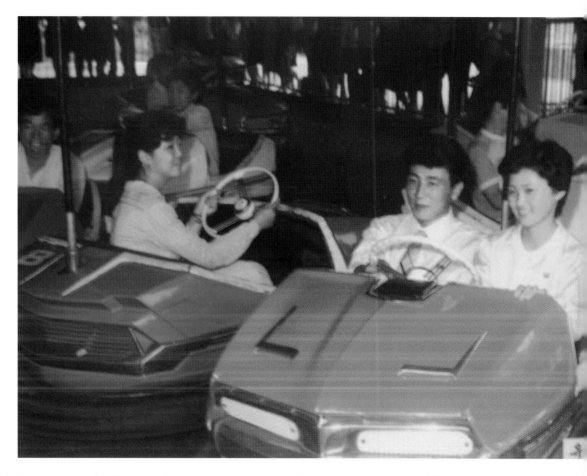

»The heroes of our art and literature are model revolutionaries who have taken a firm grasp of the great concept of Juche and are fighting devotedly to implement Party policy.«

»Everyone lives in specific social surroundings in a definite period of history; he is both influenced by surroundings, and, at the same time, reshapes them according to his own ideals and requirements.

Hence the surroundings reflect the personalities of the people who live in them. This is clearly indicated by the fact that even people who live in the same period and under the same social system each construct their surroundings in their own way.«

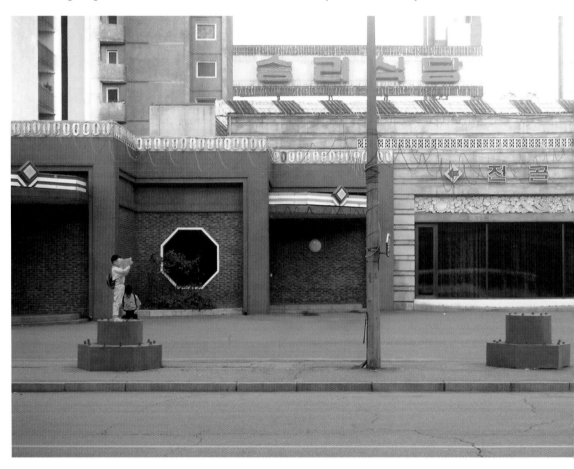

»Sets and props should be not exaggerated on the grounds that the essential aspects of life
have to be clearly and sharply expressed. This inevitably leads to the beautification and embellishment of life,
and the cinematic portrayal of reality loses its truthfulness and vividness.«

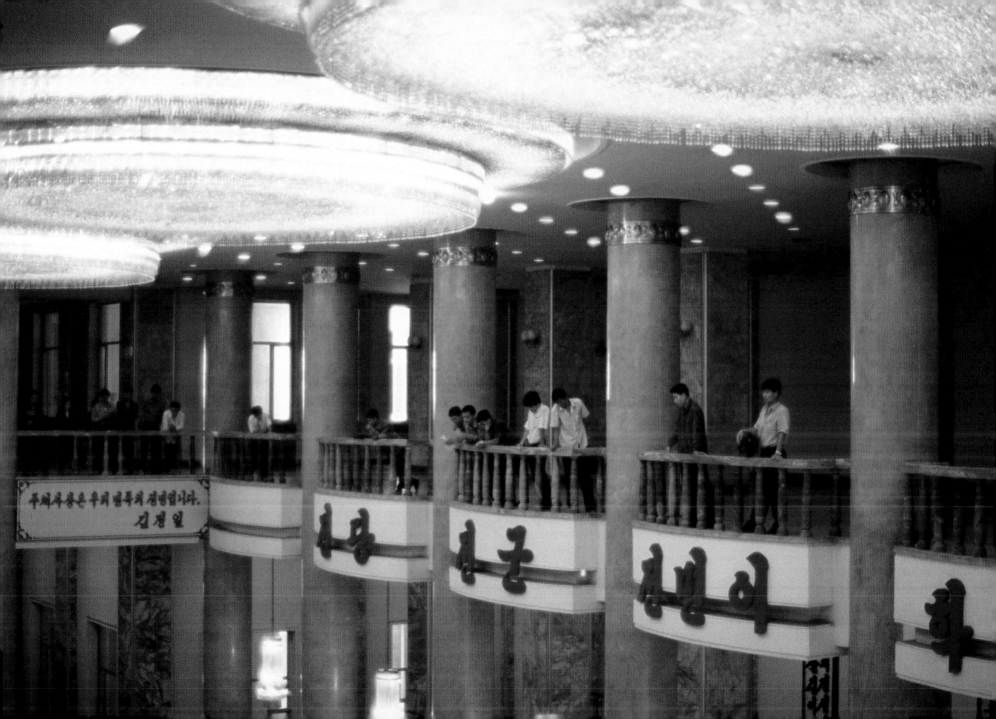

»Everyone knows the song ›My Heart Will Remain Faithful‹ from ›The Sea Of Blood‹

and the song ›The Red Flower of Revolution Is Kept in Full Bloom‹ from ›The Flower Girl‹.

Many people began to sing these songs as soon as they appeared.

The more one heard them, the more one wanted to hear them, the more one wanted to sing them.«

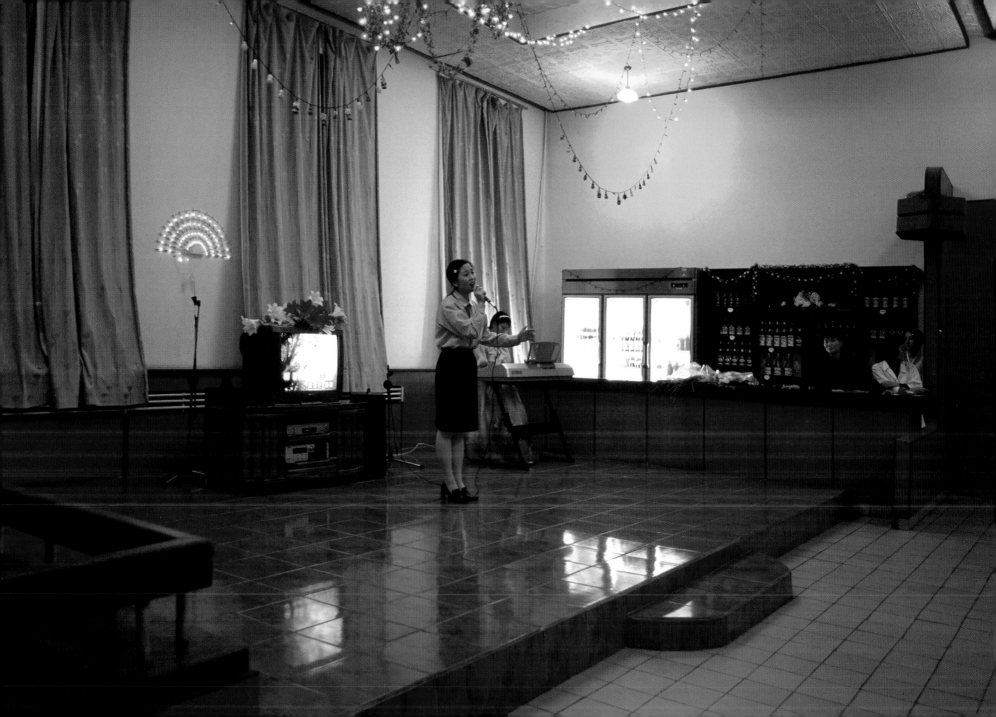

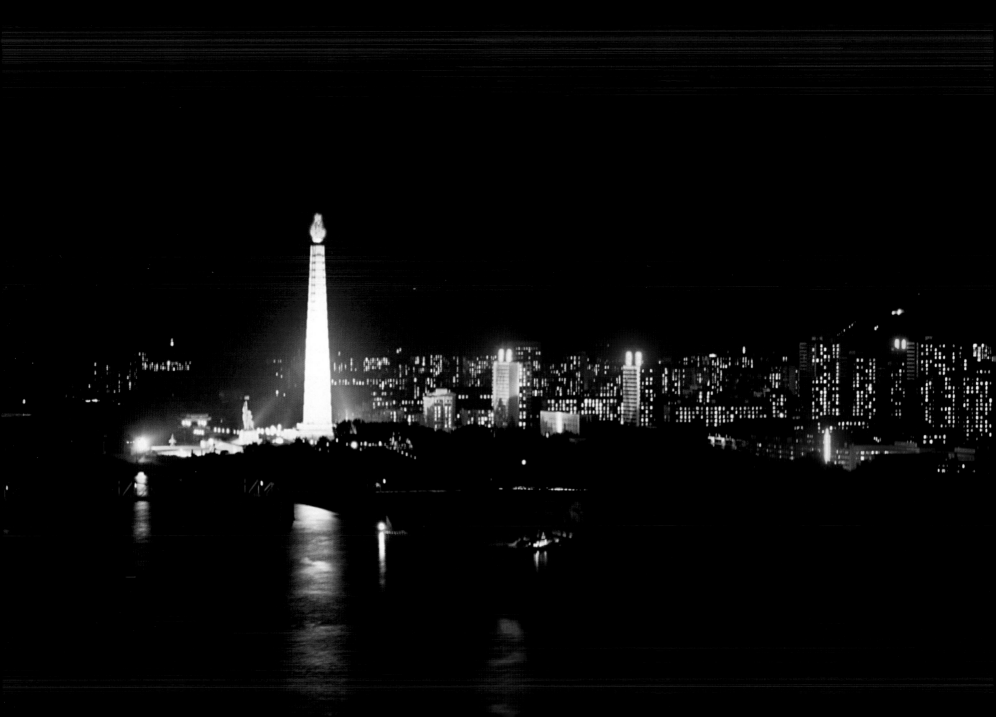

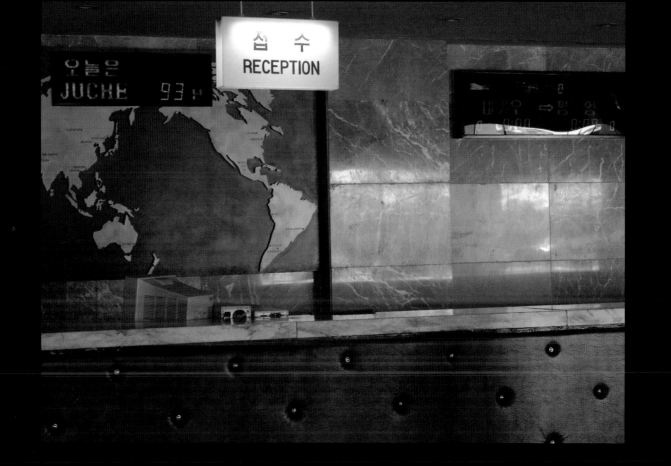

»An image which has been captured by the camera
and projected onto the screen cannot be corrected, but only cast aside.
A stage production can be revised and added to constantly
in the course of repeated rehearsals and performances
and it can be improved in any way the author wishes,
but once a film has been transferred to the screen, it cannot be altered.«

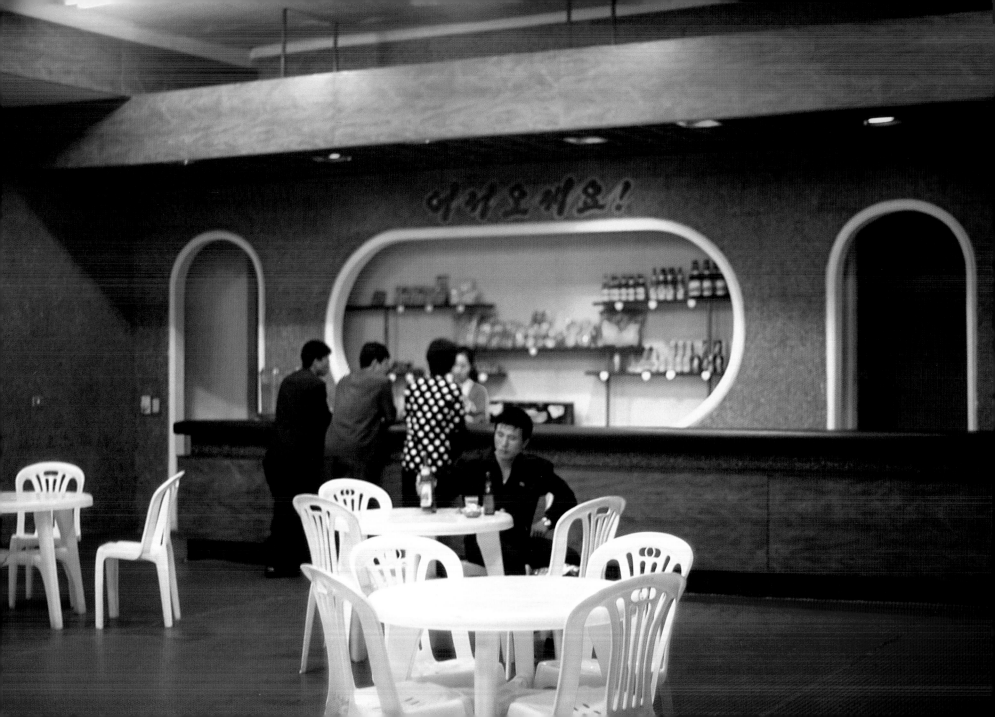

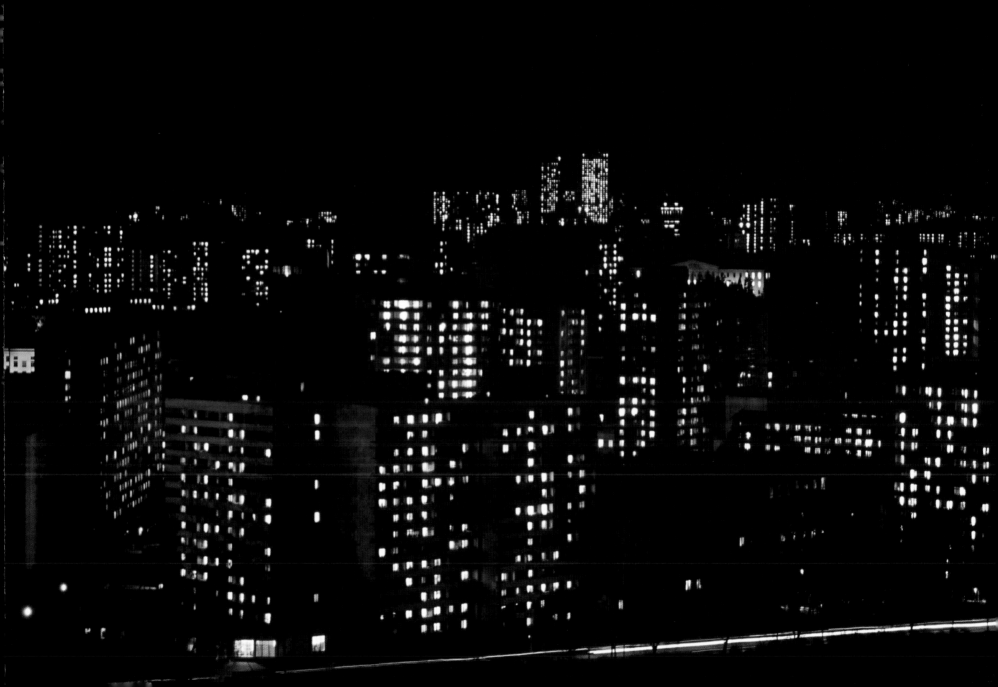

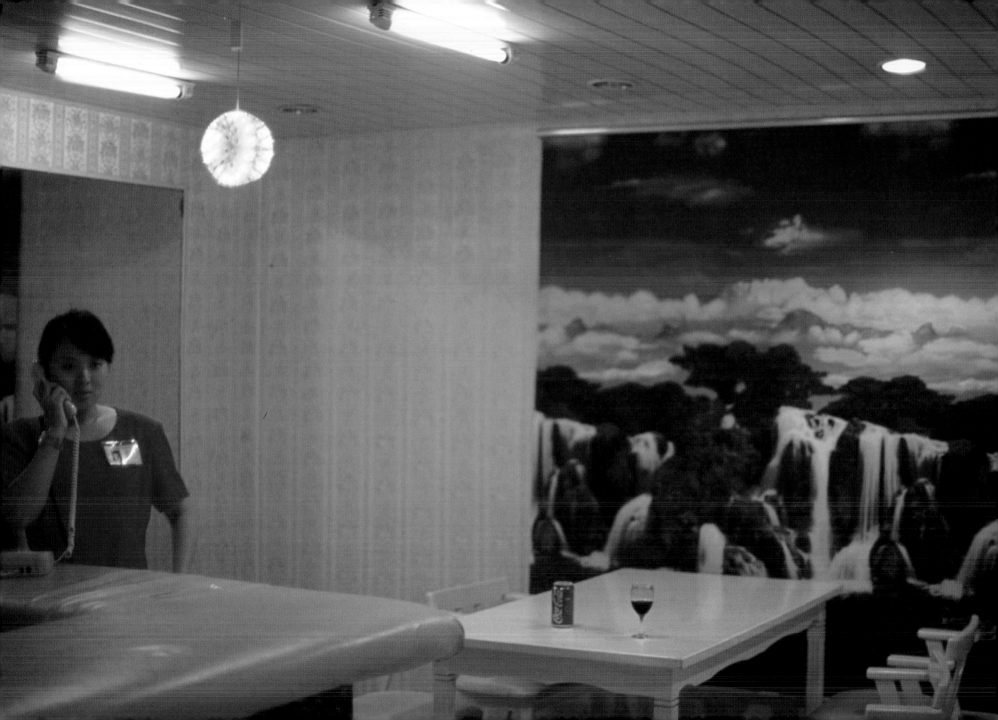

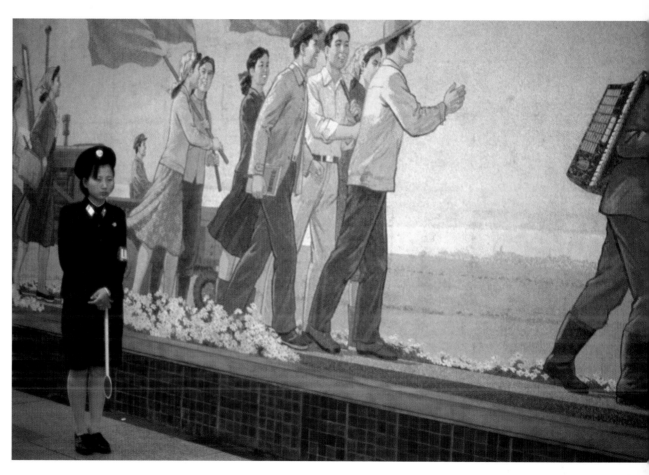

»An actor's characterization is more vivid than a depiction in words or a sketch or a portrait
and incomparably more substantial than a character depicted in the rhythms and melodies of music.«

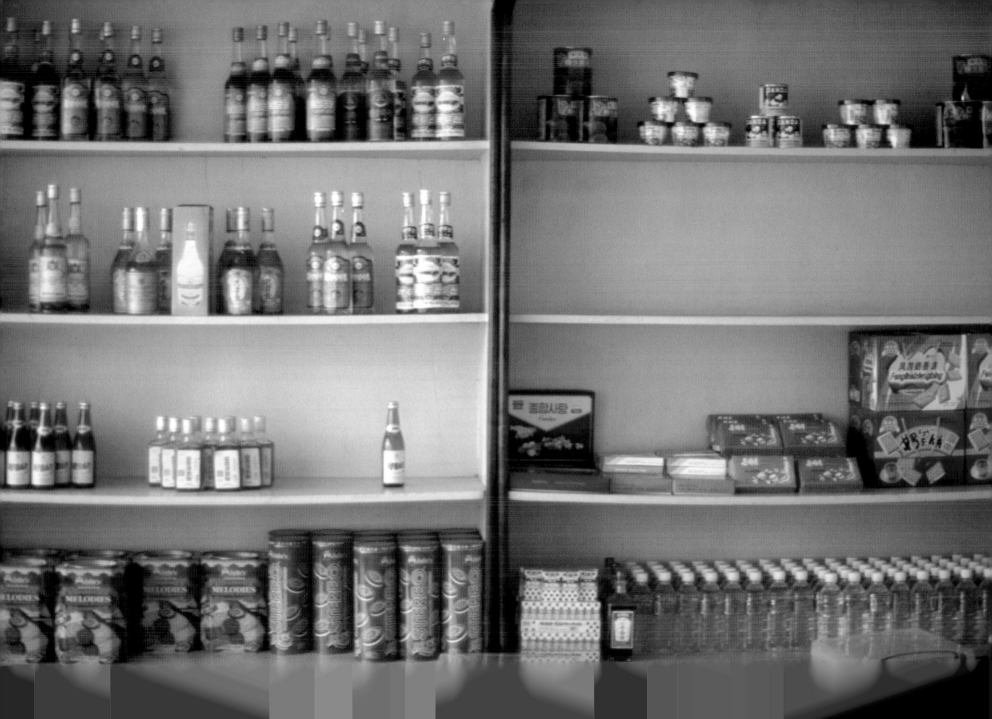

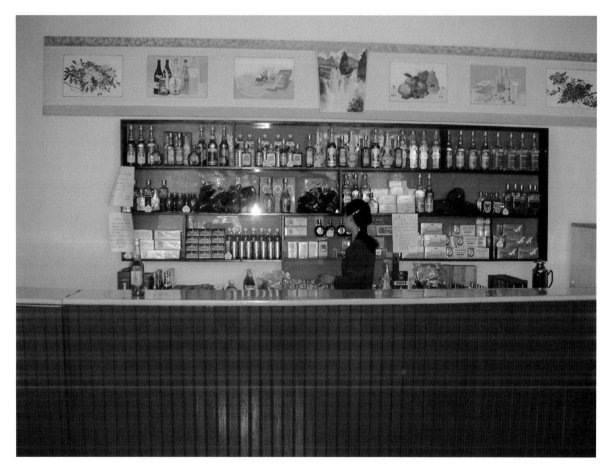

»In one film about the life of a female shop assistant, the heroine was made to change her clothes a number of times
for no particular reason ... That may seem to be trifles, but they are distortions of the truth,
which undermine the realism of the production and, furthermore, have an adverse effect on people's education.«

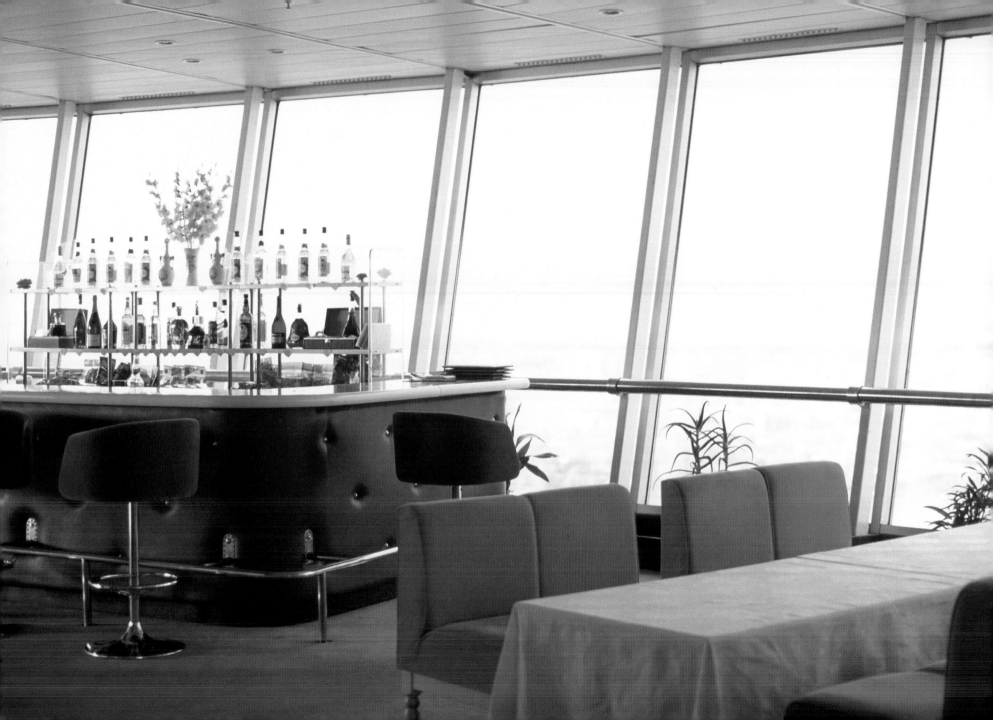

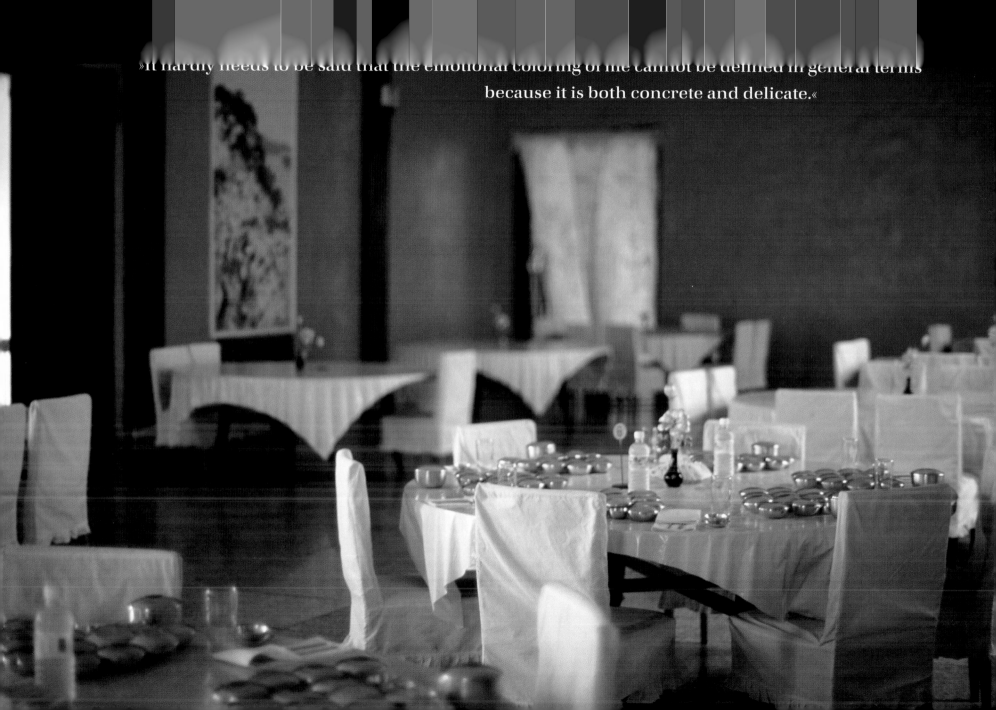

»It hardly needs to be said that the emotional coloring of me cannot be defined in general terms because it is both concrete and delicate.«

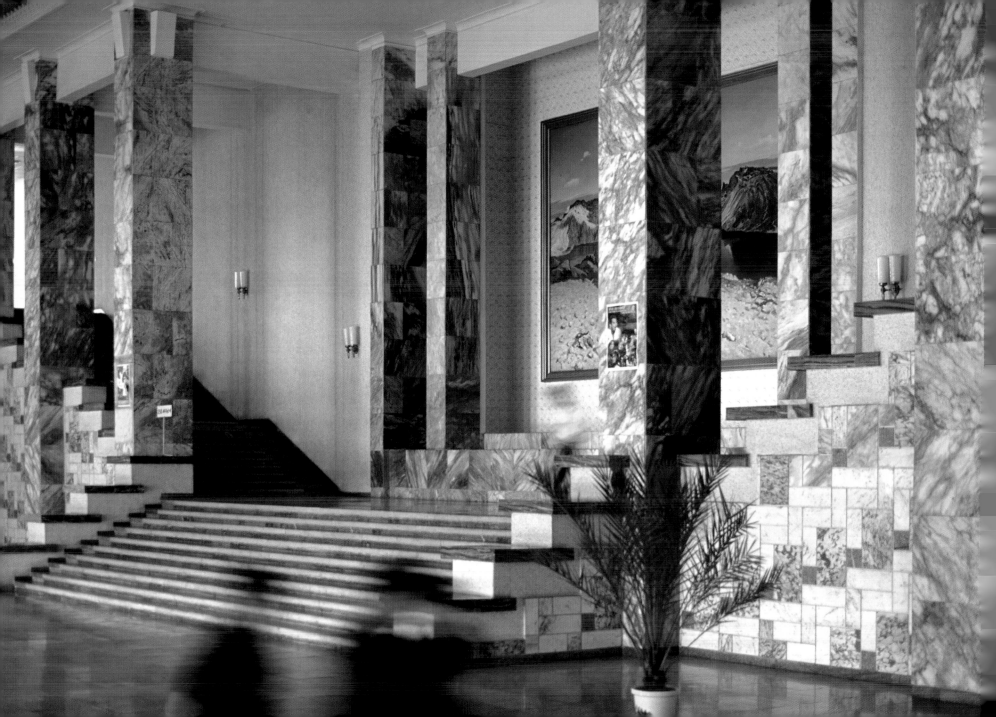

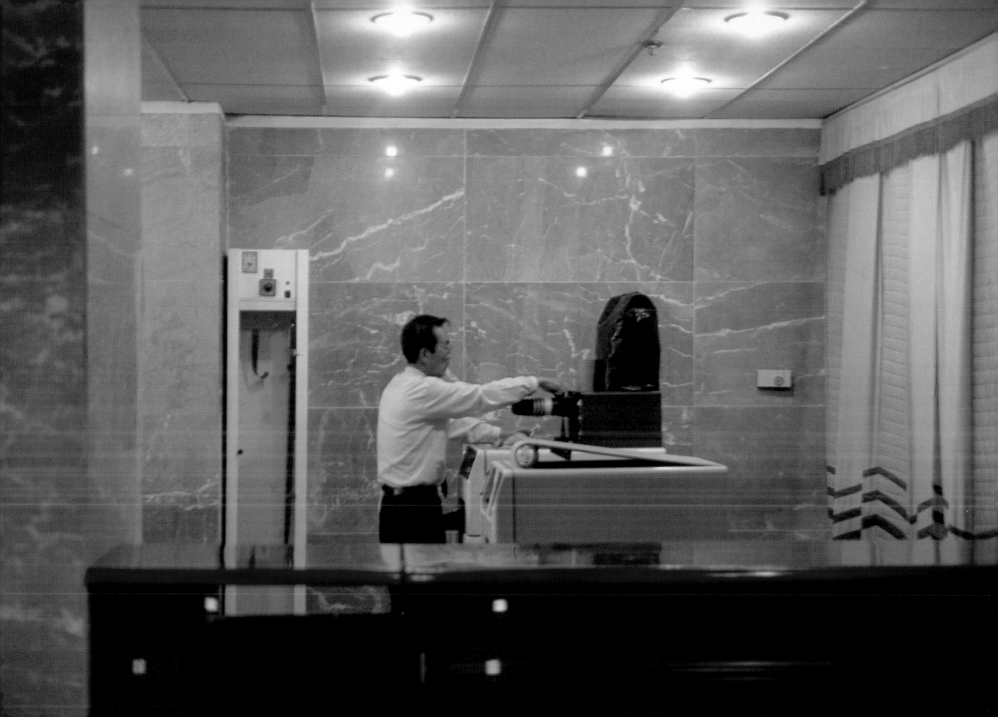

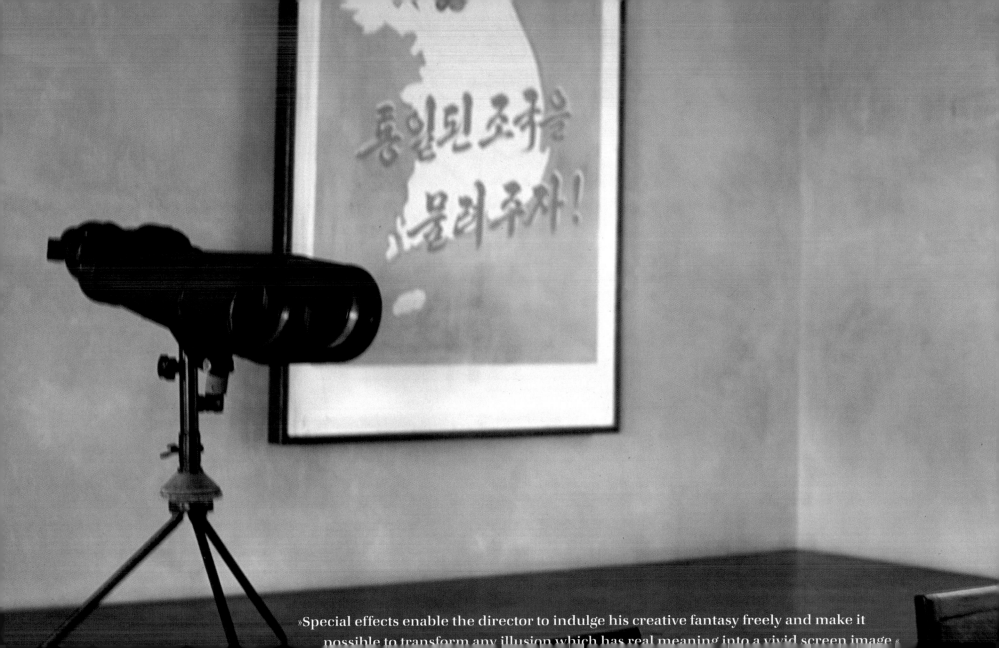

»Special effects enable the director to indulge his creative fantasy freely and make it possible to transform any illusion which has real meaning into a vivid screen image.«

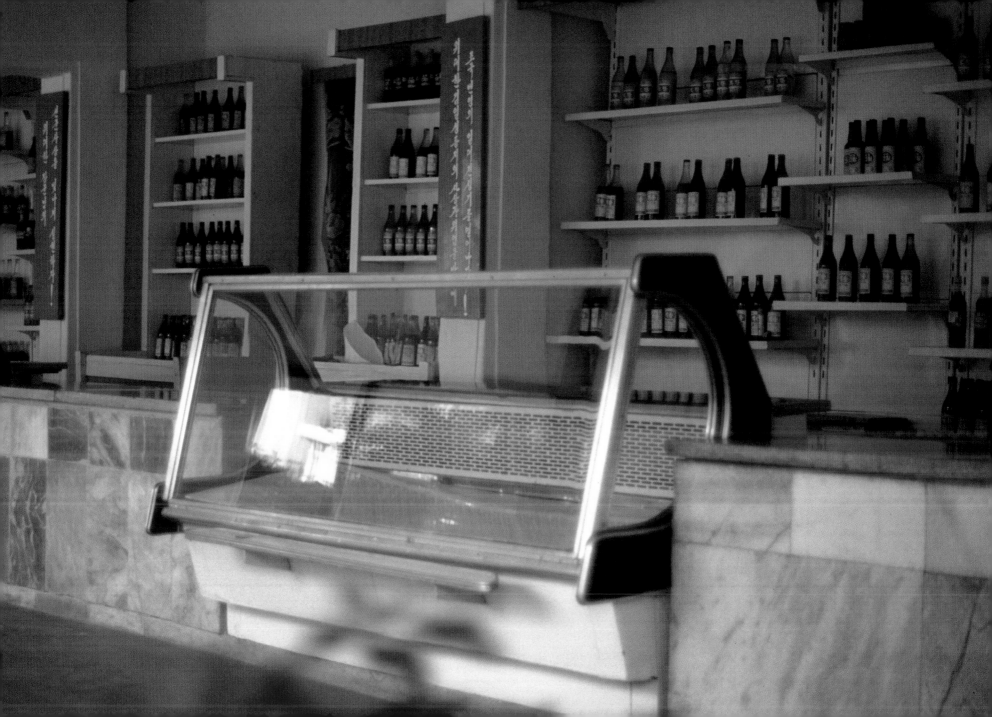

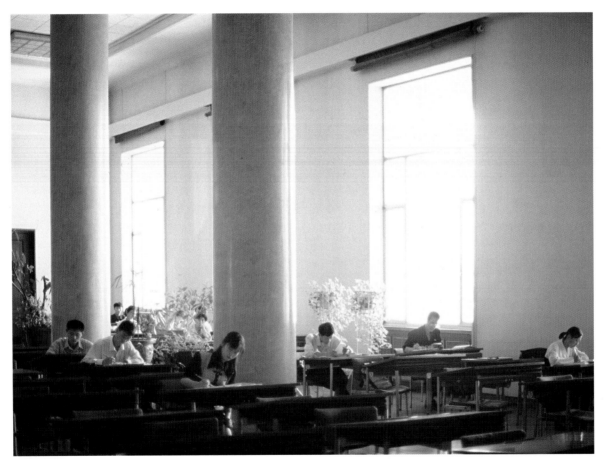

»Writers and artists find themselves in charge of one front of the Party's ideological work and directly responsible for the development of a socialist, national art and literature.«

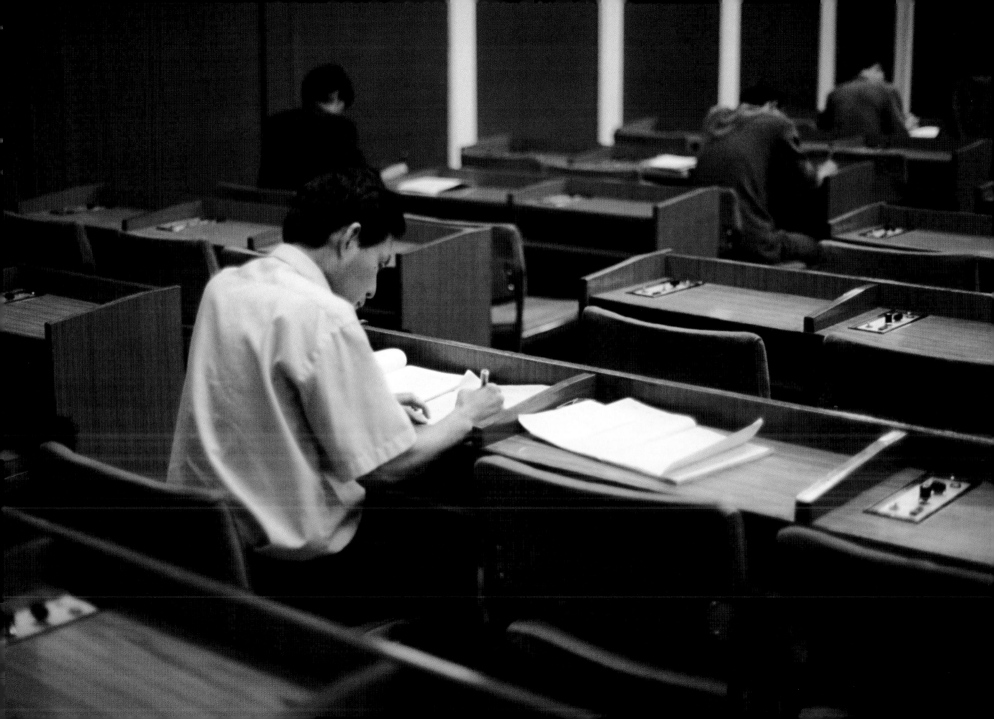

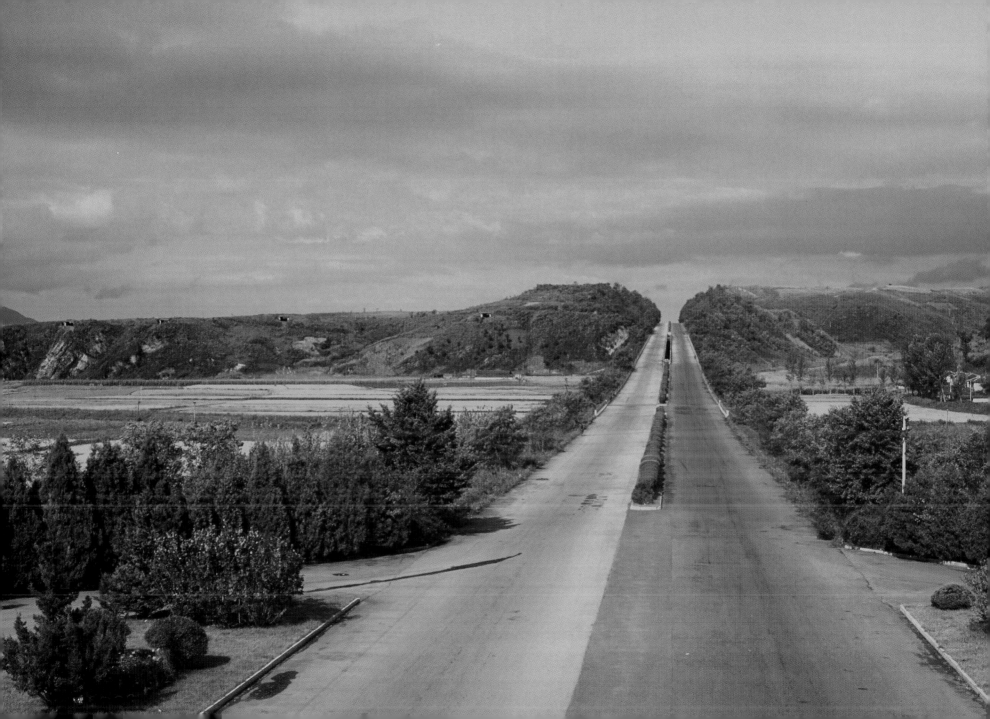

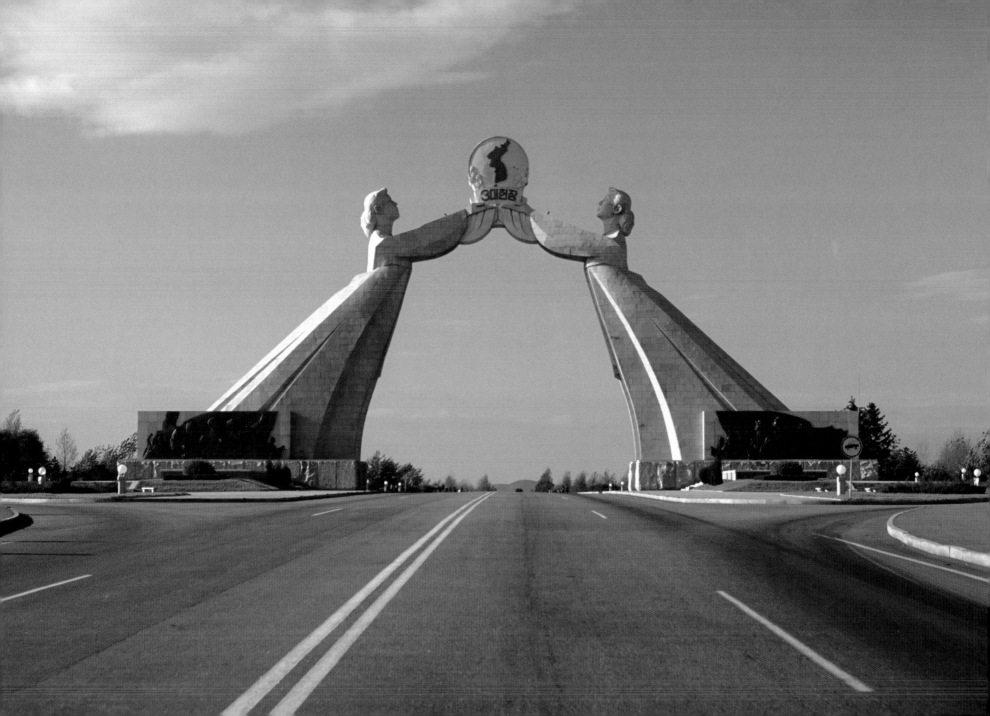

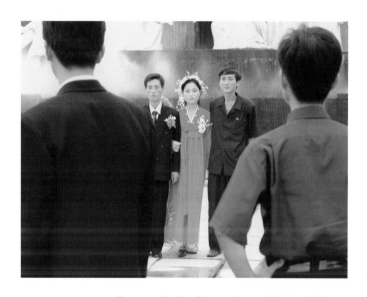

»The cameraman should depict the diverse aspects of human life
in an effective and interesting manner.
However, he should not use his camera simply to create interest,
and deviate from the depiction of the essential
and authentic nature of the object.«

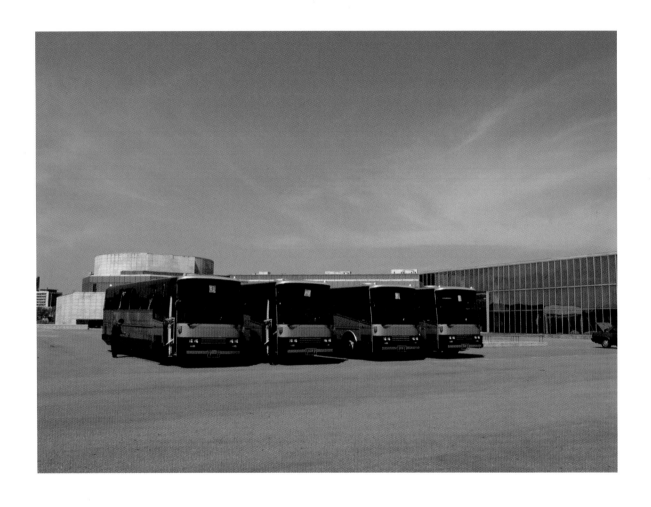

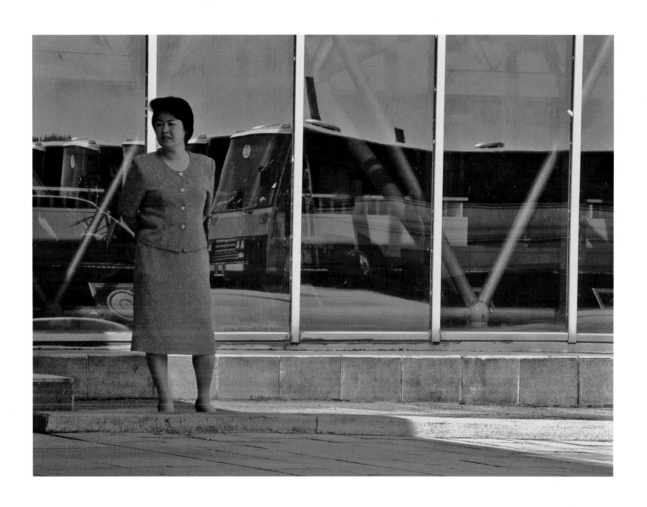

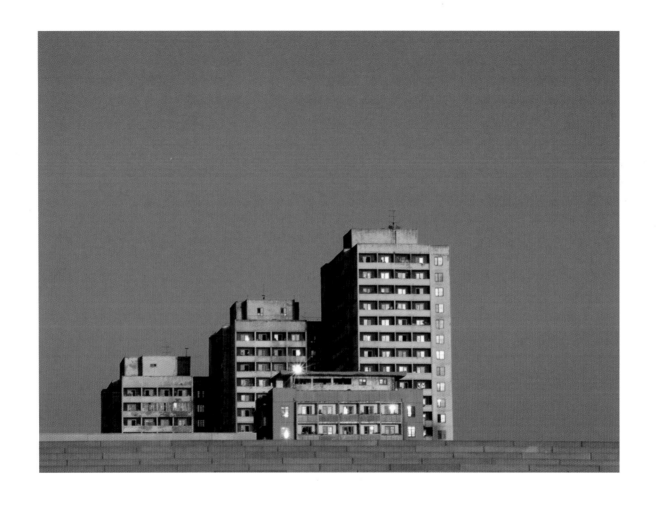

A wall of engraved plaques. Readable inscriptions include:

- DACCA UNIVERSITY BRANCH COMMITTEE BANGLADESH 28 March 1980
- JAMAICA KINGSTON ST. ANDREW GROUP FOR STUDY OF THE JUCHE IDEA MAY 8, 1981
- LYCÉE DES JEUNES FILLES DE LA RUE PACHA DE L'AMITIÉ TUNISO-CORÉENNE 16.10.1980
- CERCLE D'ÉTUDES DU KIMILSUNISME DES ÉTUDIANTS AFRICAINS À GENÈVE EN SUISSE 22 JUILLET 1976
- O COMITÉ PORTUGUÊS DE ESTUDO DO KIMILSUNISMO 10-4-1979
 - O GRUPO DE QUELUZ 22-12-1979
 - O GRUPO DE LISBOA 22-12-1979
 - O GRUPO DE AMADORA 10-10-1980
 - O GRUPO DE ESTORIL 7-2-1981
- JEAN SURET CANALE
- JUCHE IDEA STUDY GROUPS NICOSIA - CYPRUS
- STUDY GROUP OF PRESIDENT KIM IL SUNG JUCHE IDEA IBADAN, NIGERIA JULY 26, 1980
- ΕΛΛΗΝΟ - ΚΟΡΕΑΤΙΚΟΣ ΣΥΛΛΟΓΟΣ ΦΙΛΙΑΣ 25-7-1979
- CERCLE D'ÉTUDE DES IDÉES DU DJOUTCHE DES ÉTUDIANTS AFRICAINS DE L'UNIVERSITÉ DE NEUCHÂTEL EN SUISSE 18 MAI 1979
- NEW ZEALAND-DEMOCRATIC PEOPLE'S REPUBLIC OF KOREA SOCIETY 24 March 1974
- CERCLE D'ÉTUDES DU KIMILSUNISME DES ÉTUDIANTS MALGACHES À LAUSANNE EN SUISSE 8 JUILLET 1978
- DAVID BIRENE PARIS-FRANCE
- 主体思想万岁! 高井日嗣子
- NATIONAL COMMITTEE FOR STUDYING THE JUCHE IDEA IN SIERRA LEONE 15-4-1980
- COMMITTEE ON THE JUCHE IDEA AND WORKS OF THE GREAT LEADER PRESIDENT KIM IL SUNG OF THE LAGOS STATE WING OF N.U.T. OCTOBER 28, 1978
- DIRECTEUR DE L'INSTITUT INTERNATIONAL DES IDÉES DU DJOUTCHE KOUNOUTCHO SOSSAH TOGO
- BANGLADESH SELF-RELIANCE RESEARCH ACADEMY 1 March 1980
- LOUIS TERRENOIRE
- 日本青年チュチェ思想研究連絡協議会 1974年5月26日
- JUCHE IDEA STUDY SOCIETY OF DELHI INDIA
- THE MALTA NATIONAL COMMITTEE TO STUDY THE JUCHE IDEA
- VICTOR LEDUC FRANCE
- SAYE ZERBO, CHEF DE L'ÉTAT DE LA RÉPUBLIQUE DE HAUTE-VOLTA LE 15 AVRIL 1981
- MATHIEU KÉRÉKOU PRÉSIDENT DE LA RÉPUBLIQUE POPULAIRE DU BÉNIN LE 15 AVRIL 1981
- STUDY GROUP OF JUCHE IDEA OF GREAT COMRADE KIM IL SUNG LAGOS, NIGERIA JUNE 15, 1980
- Jean Claude KAZAGUI Secrétaire Général de l'Union Démocratique Centrafricaine - Bangui -
- INTERNATIONAL INSTITUTE OF THE JUCHE IDEA
- PAKISTAN LAHORE COMMITTEE FOR THE STUDY OF KIMILSUNGISM DATE OF FORM: 10 APRIL 1976
- PRESENTED BY MALTA LABOUR PARTY
- KIMILSUNGISM STUDY CIRCLE OF TRADE UNION WORKERS OF LAHORE PAKISTAN DATE OF FORM 10 APRIL 1976
- CERCLE FRANÇAIS D'ÉTUDES DES IDÉES DU DJOUTCHE
- THE GAMBIAN GROUP FOR THE STUDY OF KIMILSUNGISM 5 FEBRUARY 1979
- The Ghana National Institute of the Juche Idea July 29, 1980
- Yaya BAGAYOKO
- Comitato Italiano per lo studio della DJOUTHE' idea FONDATO 7-X-1980 ROMA
- LONG LIVE KIMILSUNGISM
- DER SCHWEIZERISCHE STUDIENZIRKEL DER DSCHUTCHE-IDEE 18 MARZ 1978
- POUR LA PÉRENNITÉ DU DJOUTCHE MUKULUMANYA ZAIRE 15-4-1981
- CHITTAGONG DISTRICT BRANCH 16 March 1980 BANGLADESH
- REMY GILLIS BELGIQUE
- JUCHE IDEA STUDY SOCIETY OF GUJERAT INDIA
- THE JUCHE STUDY GROUP OF DAR ES SALAAM UNIVERSITY JAN. 10, 1981
- YOUTH STUDY GROUP FOR COMRADE KIM IL SUNG'S WORKS INDIA 1.2.1971
- PADONOU JEAN-MARIE PRÉSIDENT DU COMITÉ BÉNINOIS DE L'AMITIÉ ET DE LA SOLIDARITÉ AVEC LA RÉPUBLIQUE DÉMOCRATIQUE DE CORÉE COTONOU - R.P.B.
- PAKISTAN RAWALPINDI ASGAR MALL STUDY CIRCLE FOR STUDYING KIMILSUNGISM

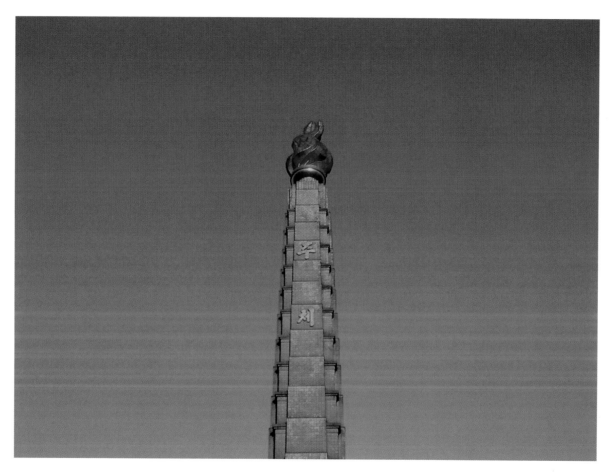

»This is the great age of Juche. The Juche age is a new historical era when the popular masses have emerged as masters of the world and are shaping their own destiny independently and creatively.«

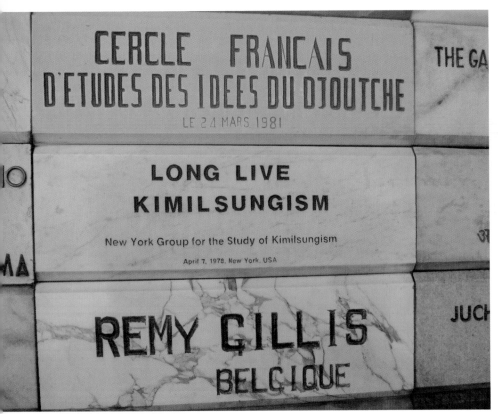

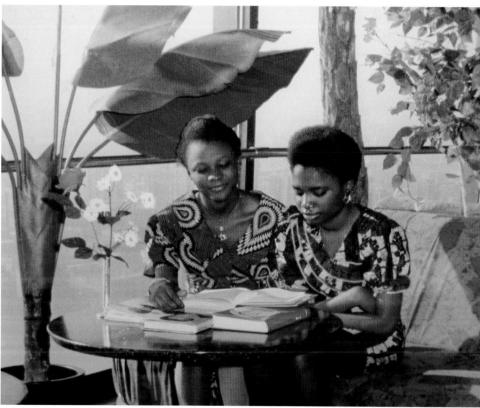

»People's appearances change as the times change,
they look different depending on the contemporary national sentiments and customs.«

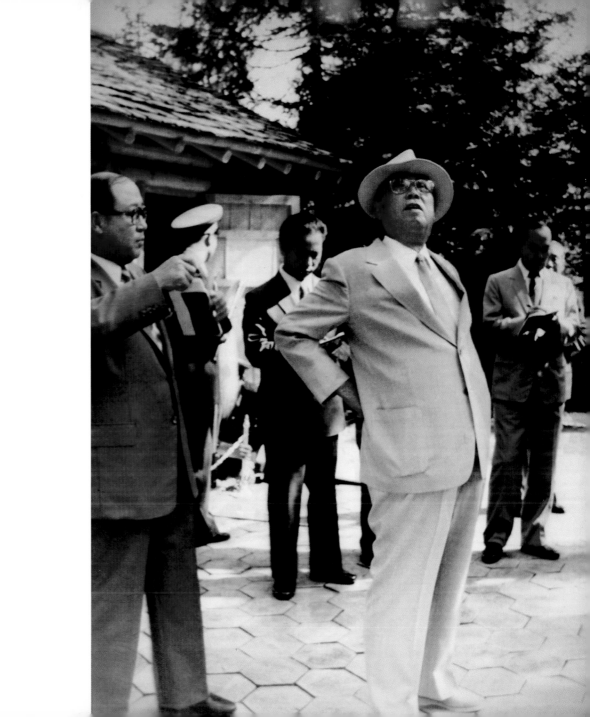

»If the ideological and emotional impact of a film is to be long-lived,
it must not drag on monotonously,
but come to its conclusion neatly and quickly.«

Copyright

The Authors

Kim Jong-Il is the leader of the Democratic People's Republic of Korea. He lives in Pyongyang.

Eva Munz is a writer and filmmaker. She lives in Shanghai and Berlin.

Lukas Nikol is a designer and photographer. He lives in Munich.

Christian Kracht is one of the most well-known writers of German contemporary literature. He lives in Kathmandu and Zurich.

Originally printed in Germany in 2005 as *Die totale Erinnerung*
ISBN: 978-1-932595-27-7

Feral House
PO Box 39910
Los Angeles, CA 90039

www.FeralHouse.com

Design: Judith Banham, San Francisco

10 9 8 7 6 5 4 3 2 1

Printed in China